Aluminum Giftware

Frances Johnson

Schiffer Publishing Ltd

77 Lower Valley Road, Atglen, PA 19310

With Prices

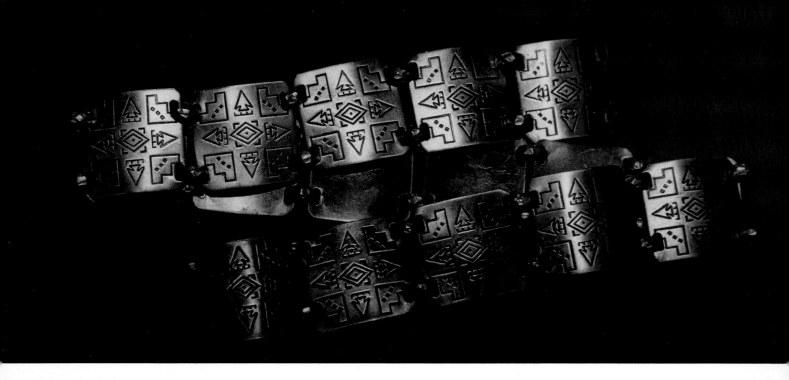

Printed in Hong Kong

ISBN: 0-88740-830-3

Book Design by Audrey L. Whiteside

Library of Congress Cataloging-in-Publication Data

Johnson, Frances.
　　Aluminum giftware/by Frances Johnson.
　　　　p.　　cm.
　　ISBN 0-88740-830-3 (paper)
　　1. Aluminum giftware--Collectors and collecting--United States--Catalogs. I. Title.
NK7700.J64　1996
739.5'7'075--dc20
　　　　　　　　　　　　　　　　　　95-35897
　　　　　　　　　　　　　　　　　　CIP

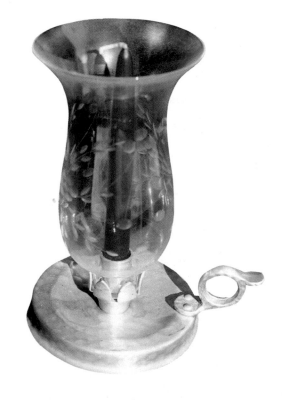

Published by Schiffer Publishing, Ltd.
77 Lower Valley Road
Atglen, PA 19310
Please write for a free catalog.
This book may be purchased from the publisher.
Please include $2.95 postage.
Try your bookstore first.

We are interested in hearing from authors
with book ideas on related subjects.

Contents

Introduction

In the 1940s a friend gave me a gift she had made — a round aluminum tray with a floral design. She learned how to make the tray by covering everything except the design with a type of wax, then put acid on the uncovered portion. Actually the acid was put on a portion of the design, one step at a time, unless the design was supposed to be the same all over. It was a rather tedious operation as the wax had to be put on just so and the acid applied correctly.

The technique was being taught at Home Demonstration Club meetings as well as in some hobby and craft shops. The instructor might furnish the supplies, or they could be bought at the hobby or crafts shops.

Some of the hobbyists were quite skilled and very talented, and therefore made some pieces that were absolutely beautiful. Like other crafts and hobbies there were some who weren't so skilled nor so talented. Their work left much to be desired. In fact, some of those pieces haven't survived and those of us who remember them don't consider that too much of a loss.

Like the needlework, basketry, china painting, and pyrography of a half century before, the makers wanted to share their handiwork with friends and family. So in some areas the homemade aluminum became the most popular, inexpensive gift of the late Forties and early Fifties.

Prior to that time some hammered and forged aluminum had been made, but with the returning servicemen and their families trying to establish homes for the first time the demand for aluminum giftware escalated rapidly. To satisfy the demand hammered aluminum forges began springing up all over the eastern part of the United States, but mostly around large cities. Those pieces didn't entirely replace the homemade variety, but the forge-made pieces did become one of the more popular wedding gifts of that period. In fact, it wasn't unusual a few years ago to see numerous pieces at yard sales. The seller would confide, especially if asked, that the pieces were wedding gifts dating back 25 to about 50 years. When new or what they thought were more modern products came along the seller had simply stored the hammered aluminum and forgotten it. When yard sales became a way to dispose of unused and unwanted items, the aluminum was among the first things to go.

In the early 1980s nostalgia overcame me and I began to buy a few pieces. At that time prices were more than reasonable, actually they were downright cheap. Seldom was a piece priced over $2, usually 50 cents to $1 each. As I acquired more and more pieces I began studying the designs and the workmanship. It wasn't long before an appreciation for the beauty of the designs and the intricate workmanship on some pieces replaced the nostalgia.

I then discovered the durability of aluminum — after breaking three choice pieces of china and glass in a two week period. Beauty plus durability cinched my obsession and I was on my way to the beginning of a very satisfying period of collecting.

Another interesting feature of aluminum giftware is the variety of pieces and patterns available. There seems to be no end to them. After a dozen years or more of avid collecting, I still find pieces I've never seen before. It may be years before one even sees duplicates. Of course we all know that different areas have a great bearing on the availability of antiques and collectibles in a particular area. I just happened to live in an area with a bountiful supply of aluminum. If you are looking for something to collect that is beautiful, unbreakable, still rather plentiful, and reasonably priced, you can't beat aluminum giftware.

The popularity of aluminum giftware seems to be experiencing a revival, a mighty revival. Not since it enjoyed so much popularity as the most acceptable wedding gift a half century or so ago has it been so sought after.

Part of this early popularity can be attributed to the fact that World War II had been long and grueling. As the servicemen returned home and got married there was probably more demand for wedding gifts than at any other given time in history. Money wasn't quite as plentiful as it is today and with stacks of wedding invitations, the average person just had to cut a few corners. Not everyone could afford to give sterling silver gifts, but they did want something glitzy. Hammered aluminum seemed to be the answer. Even silver companies got into the act and started making beautiful hammered aluminum pieces. So much was made and used it soon became known as the "Poor Man's Silver." It did and still does have some of the appearance of silver, especially the pieces with designs similar to sterling silver pieces.

War brides didn't have any excess money in those early years as they began to buy and furnish their homes. Aluminum giftware was one item they could not only afford to buy and use but could also give as gifts. This was also a time for entertaining at home which meant the large trays, beverage sets, chafing dishes, ice buckets and other pieces were used regularly. Many pieces were used by the family on a regular basis. It would be difficult today to find any one married between 1940 and 1970 who didn't have numerous pieces, most of them wedding gifts. Incidently, there was also a lot of cast aluminum cooking utensils made and sold during that period — and earlier. They don't seem to be that collectible yet, but there is a noticeable amount being seen in antique malls and flea markets these days.

One thing that probably dampened the use of aluminum a few decades ago was the report, never verified, that the use of aluminum in connection with food was dangerous to one's health. The same rumors surfaced during the heyday of graniteware use in cooking utensils. That one was finally laid to rest when extensive research was done. Whether the same kind of research was done on aluminum is unknown, but there are no reports of its use being injurious to anyone's health.

In the field of collecting, aluminum can only be classed as a collectible because of its late manufacturing date. However, there was a time, not too long ago, when the determining factor in establishing the credibility of an antique was age. Sometime after World War II the rules were relaxed and 100 years became sufficiently old enough to class a piece as an antique. To some those rules still apply. Then there was a group that decided the rules should be relaxed even more. Or maybe some collectors just decided to collect what they liked, regardless of age. Whatever the reason there are now thousands of people collecting things from the 1950s. That date seems to have a strange fascination for young collectors.

Perhaps this situation stems from the fact that collectors have increased so rapidly, while the number of genuine 100 year old antiques has decreased -- actually they haven't really decreased, as few have been destroyed, but have rather simply been absorbed into museums and private collections, leaving less for the new collectors. Every now and then a museum will deassession some fine things, but there will be hundreds of moneyed collectors standing by to pay fabulous prices for those pieces. This leaves the young, less affluent collector without much clout and even less buying ability. It also leaves young collectors with only a couple of choices: Spend time and money looking for that elusive, genuine antique, or accept the later, less expensive pieces.

Today nostalgia seems to be playing a big part in collecting. More and more, it seems young collectors are trying to save things they remember from grandma's house. It was ever thus. My generation wanted to save all the cut glass, sterling silver, art glass, and Haviland china from the turn of present century. Some of it hadn't yet reached the 100 years required to class it as an antique, but we collected it anyway. The generation before us had worked long and hard to collect the fine old flint glass and fine furniture of an earlier era. Now the young folk are collecting Depression glass, oak furniture, and hammered aluminum, things they remember from their childhood.

Aluminum giftware is about the same age as Depression glass and oak furniture and hammered, polished, forged, and hand wrought aluminum dates from around 1930 to about 1970. Although it is the

most plentiful metal in the world and experts say there is no chance of our supply running out for thousands of years, it was not identified until 1807 when Sir Humphrey Davy discovered it. The reason, they say, for it having not been found earlier was the fact that when the earth began to cool, aluminum became combined with other components and was no longer in its natural state.

Although people at that time were not able to enjoy aluminum in its natural state, they did create some wonderful things by combining it with other components. For instance, emeralds, Oriental amethyst, rubies, and sapphires were formed when aluminum was combined with oxygen. Apparently it was a great mixer as it mixed with so many other things. Garnets were formed when it was mixed silica, or it would mix with phosphate to form turquoise. Jade was formed from a mixture of silica, sodium, oxygen, and aluminum.

Not all the problems were solved just by establishing its very existence and discovering how to mine it correctly. One of the first problems was solved when a Danish scientist named Hans Christian Orsted was able to identify it. In 1825 he produced a small pellet of aluminum. It was described as having the color and luster of tin.

It is still sometimes difficult for beginning collectors of hammered aluminum to be absolutely certain the piece is aluminum rather than tin as both are very light in weight and very shiny. It further hinders the task when tin pieces are hammered, have designs like aluminum, and are made in the same pieces. Actually the light weight of aluminum is one of the best ways for beginners to distinguish between aluminum and other materials. Some pieces of thin, lightweight pewter can cause confusion as can tin and pieces mixed with different alloys. Since tin can cause the most confusion, a good rule of thumb is to remember that aluminum corrodes while tin rusts. That is only to help beginners on their way because collectors quickly learn to recognize aluminum without even touching it. Another thing that helps beginners as well as some advanced collectors is the fact that many of the better pieces have the maker's trademark on the bottom, usually with the word aluminum included. It is easy to buy and confuse these pieces until one learns to tell the difference.

Around 1845 a German scientist named Frederick Woehler was able to produce aluminum in a gray powder form. Ten years later a French chemist named Henri St. Claire Deville had developed a method for producing marble-sized lumps of aluminum. This was a wonderful break through in the discovery of aluminum, but it had devastating effects on the market. Whereas in 1845 the price of aluminum had been around $545 a pound, it quickly dropped to $17 with Deville's discovery. The drop in price still didn't increase the use of aluminum as it was still considered too expensive for use in anything except jewelry.

The big discovery which everyone had been waiting for came in 1886 when an American named Charles Hall and a Frenchman named Paul Heroult discovered, simultaneously, a process for producing aluminum that was both easy and inexpensive. This new discovery sent the price of aluminum plummeting to $5 a pound. One would have thought this lower price would have encouraged the use of aluminum in the manufacture of nearly everything. Unfortunately, it didn't. But the demand did increase. By 1900 the price had dropped to 33 cents a pound. Of course that price did encourage manufacturers to search for ways to use it, but it would be another couple of decades or more before it would be widely used. By the early 1930s some of the famous Rolls-Royce automobile bodies were being made of aluminum. A few other car makers followed suit and began making their car bodies and some of their engines of aluminum. During that time it was also used in some architecture and in furniture making. It is still being used in many of those projects.

Many might want to collect the aluminum bodied Rolls-Royces, but few can afford them, even if they could still be found. For that reason those who like aluminum will probably have to settle for the later giftware. These pieces have many advantages. Probably first and foremost are the prices, which are still reasonable. But they are increasing rather rapidly as more and more people discover the beauty and desirability of fine aluminum giftware.

Collectors have a tendency to try to compare the original price of an antique or collectible with its present price. Until recently, the original price of aluminum giftware was much higher than that found today, but prices have been increasing recently which means that the present day prices are about the same as the original ones. Much of the following information was found several years ago when we began trying to find a "starting date" for the manu-

facture of aluminum giftware. Not much history on these pieces has been recorded yet, nor is likely to ever be because each forge's manufacturing project was so short -- all told not lasting but about thirty years. And in that thirty years, the aluminum giftware was made in at least a 100 or more small forges scattered around the country. Some were prolific makers while others apparently made only a few hundred pieces. As far as is known Wendell August Forge is the only forge still making aluminum giftware. The forge moved to Grove City, Pennsylvania in 1930 and is still located there.

A concentrated effort to find as much information on as many small forges as possible was undertaken a few years ago, and we finally came to the realization that it would require a trip to each and every town where a forge had been established. Even then we weren't sure how much and what kind of information could be obtained. Letters to libraries and historical societies failed to uncover much information as we were informed there were no records, or there were not enough employees to check for material. Unable to find much history that way, we turned to the old advertising, either magazines or catalogs. Since little could be found in magazine advertising, it confirmed our first theory that many of the forges were small, at least too small to think it worthwhile to do extensive advertising.

Compared with magazines, the catalogs, or at least a few of them, were virtual gold mines. In various catalogs from Ovington's, the fine gift shop located at 437 Fifth Avenue, New York City, from around the turn of the present century until they closed in the 1940s, we found several pieces advertised. One of the most interesting things we found was the fact that the same pieces which had been made in copper, brass, silver plate, sterling silver, and pewter prior to 1930 began showing up after that date in aluminum. Another interesting thing was the fact that the aluminum pieces were not much cheaper than the earlier silver plate, brass, copper, and pewter. Beginning in 1934, two pieces of aluminum giftware were offered in a small catalog entitled *Book of Gifts for the Bride*. One was a 13.5 by 21 inches tray decorated with ducks or geese in flight. It was priced $15, and that was in 1934. The other piece was described as a new "essential" and was a kind of tray. It was 16 inches in diameter and designed for cheese, relish, and crackers. The colorful tile in the center could be used for slicing cheese, they said, while the sunken

wells around the rim could be used for relish. It was described as "ideal for supper and buffet parties," and was priced at $20.

Aluminum giftware was trying to find its niche during those early years, and for that reason there were pieces of polished aluminum as well as hammered. Interestingly, silver and copper decorations were used on both, but in limited amounts, it seemed.

One of the first sets found in the Ovington catalogs was described as "Pilsener à la 1933." It consisted of a quart size aluminum jug or pitcher, six tumblers, and a tray. It was described as a way to "Treat the legal lager with the honor and distinction it deserves." The price for the set was $9.50. A polished cooler was offered in the same catalog. It was designed to hold four bottles of beer, or the rack could be removed to turn it into a wine cooler. Price on this one was $5. The next year they were offering a yachting scene tray that measured 11 by 17 inches for $10.

In the 1934-35 winter catalog Ovington was offering what they called the "new metal," further described in this way: "Light and lovely Kensington is the newest thing in metal designing. Untarnishable, it has the soft lustre of old silver. Is decorated with antique brass mounts." Today this giftware is probably one of the most sought after of the aluminum collectibles. Comparing the prices then with prices today might be interesting. In 1934-35, a 6.5 inch candy box was offered for $5, a 10 inch vase $9.50, and a 5 by 7 inch tall tobacco jar was $6. Kensington was the trade name used by The Aluminum Company of America for pieces made at their New Kensington, Pennsylvania, plant. The mark or logo on these pieces is the letter K with a deer's head above and the word Kensington underneath.

In 1941 Carson Pirie Scott & Company, Chicago, Illinois, devoted two pages of their catalog to aluminum giftware made by Everlast. The pieces were described as ideal for Dutch suppers and appetizers. This was a time when more entertaining was done at home than any place else. The suggestion they gave for keeping the aluminum shining should be equally as helpful today: "Everlast treated aluminum is impervious to alcohol and acid stains. Soap and water is all that is necessary to keep these handsome, handforged pieces permanently lustrous and beautiful." Of course so many of the pieces found today haven't been properly cared for, and therefore will be pitted and corroded when found. But once they have been cleaned correctly, it should be easy to

keep them bright simply by washing with soap and water.

The Everlast pieces were described as being made of extra heavy gauge aluminum and this seems to have been true of all Everlast pieces as those found today are of good quality and the workmanship excellent. These pieces were also described as excellent for gift giving while some were described as being the delight of hostesses. Prices weren't too high considering the economy of the era. A 7 by 20 inch tray was priced $2.50; tray, 16 inches in diameter $3.75; tray with eight tumblers, glass tumblers with aluminum coasters, $6.75; 11 inch fruit basket $3.75; and an ice bucket called a "kooler," $6.75. A regular ice tub was priced $5 while an ice pitcher with lip was $3.50. Another pitcher they called a regular early American shape was priced $5.50. Both pitchers were plain, that is, having no design.

Following the two pages describing and picturing Everlast aluminum there was one page devoted to the hand wrought aluminum by Arthur Armour. It was described as "The Aristocrat of Metal lines," and the prices seemed to bear that out. First, they offered a description of his work: "A great craftsman practicing an ancient art, has taken a modern metal and wrought it into useful things of wondrous beauty! The metal is aluminum, having all the charm and beauty of solid silver. It will not tarnish. It requires no cleaning or polishing agent other than water and a soft cloth. The exciting designs are in repousse. Do not mistake for hammered aluminum. It is hand wrought and in a wide variety of pieces and designs." Prices on the Arthur Armour pieces in 1941 were $10 for an 18 inch in diameter supper plate described as ideal for buffet serving. Or for the same price one could buy a 12 by 17 inch tray decorated with dogwoods and butterflies. A bread tray that could also be used for rolls or celery was priced $4 while a 15 by 18 inch basket/serving tray with a design of oranges and orange blossoms was priced $12.75. The cocktail tray with the design of a ship, or as they described it, a "schooner," sold for $6.50. Most if not all Armour pieces are marked with the capital letter A.

Fortunately, most of the finer pieces, and they are many and varied, are marked with some kind of trademark usually the name of the manufacturer along with other marks and sometimes the pattern name. One such name found on some of the heavier, plainer pieces is the word Buenilum that was one of the several trade names used by Buehner-Warner.

They made rather plain pieces of very shiny aluminum. Most of their pieces will have a beaded border and the majority of pieces have looped metal handles and finials with what one collector calls a "shell" on the end. The company was located in East Norwalk, Connecticut, according to a woman who lived there and received many pieces as wedding gifts. Some of their pieces, such as a couple of chafing dishes, have wooden handles and finials. The majority of their pieces are plain, without a design, but like everything else in antiquedom there are exceptions.

Each maker as well as certain designs seem to be attracting their own collectors. There are collectors now who prefer certain pieces like candle holders, beverage sets, or butter dishes. Then there are collectors who prefer the work of certain makers. The aluminum giftware made by Rodney Kent Silver Company is fast becoming very popular. Kent made silver plate as well as sterling silver pieces. He also made very fancy aluminum giftware, which has caused a bit of a problem for some collectors. The name of the company which includes the word silver is on the bottom of many of their pieces, and beginning collectors immediately think the piece is silver, if not plated. Price tags have been seen on aluminum pieces in malls which describe the piece as silver — and they have priced it accordingly. It is easy to be confused as he did make quality aluminum.

Aluminum's strongest selling point then and now is the fact that it doesn't tarnish, nor is it breakable. For these two reasons alone it is a joy to use and beautiful to display. The silver color against a blue background is very eye-catching. All aluminum was silver colored until later years when apparently quality and prices became very competitive. It became necessary for the makers to cut quality by making thinner pieces of aluminum. They also made pieces that were machine-stamped as opposed to being hammered, and they made anodized pieces, pieces in a rainbow of colors. The majority of those pieces were either bowls or beverage sets. Looking back it seems there were many more tumblers than pitchers displayed in the stores. The 10-cent stores of that era carried stacks of anodized tumblers in a myriad of colors. They were unbreakable which meant they were a favorite of families with lots of children. They were also great for taking on picnics or to the beach. They were later replaced by unbreakable plastic tumblers.

Apparently there is a greater demand than supply for the older tumblers today as some of the mail order catalogs are advertising anodized aluminum tumblers and ice cream bowls priced at $10.99 for four tumblers and $13.99 for the same number of ice cream bowls. This is probably only the beginning. As prices rise, and they surely will as the popularity of hammered and anodized aluminum continues to soar, more and more forges will open and begin making aluminum again. This is true of any collectible — and some antiques. When prices get high enough to assure a good return, somewhere people will start making the product again.

To avoid many of the pitfalls it is suggested you begin studying aluminum giftware now, and first decide whether or not you like it, and then begin studying and comparing. Prices are rising, but they are still cheaper than the majority of handmade things. The choices are also good. Not as good as a few years ago, but it is almost impossible to go to any flea market or mall without seeing a few pieces.

Note on pricing: It would be physically impossible for any one person, even with the help of friends, to compile a price guide that would be perfect in every area of the country. We also have to consider aluminum made in foreign countries as pieces have been found that were made in Japan or France, Italy, Spain, England, and Beruit. If American-made pieces are found where one of the old forges was located, chances are it will be more plentiful there than in some small village a thousand miles away. It should also be cheaper where there is a plentiful supply than where it is very scarce. That also covers the second pricing problem, availability. Then there is the question of popularity. In areas where there are a number of avid collectors the price is just naturally going to be higher than in that small village where there are only one or two collectors, if that many. And then there are times when no one can account for prices that may be very high or very low. One example is the hammered aluminum condiment that sold for $50. We heard about it while checking prices in malls in several states. While still checking prices for this book we heard about a pair of average size, rather plain candleholders that had sold for $28. The highest price seen on candleholders prior to this time was $15 for a fancy pair. While still checking prices we also found a lovely grape designed silent butler for $2, a lazy Susan made by Wilson Specialties priced $3, and four anodized ice cream bowls for $1. Prices on aluminum haven't leveled off and stabilized yet which means everybody has to shop around.

It may sound like a big problem with fine antiques, but there is a marriage problem even with aluminum giftware as well. As prices rise on any antique or collectible, people who are either uneducated in the field or are trying to make a quick buck will put two odd pieces together to make one. It behooves the collector to study and learn the different styles and decorations. The first example found of the marriage problem; that is, putting two different pieces together, was putting a rather plain casserole dish on a Rodney Kent chafing dish stand. It didn't look too bad and would have been all right had the owner used the two pieces for her personal use. It wasn't all right when a dealer tried to sell it as a perfect piece. The latest example of this was a plain pair of Continental candleholders with large pattern glass bobeches. But the seller was honest enough to put a price on each piece, $35 for the bobeches and $18 for the candleholders. A novice might not have noticed that and thought they were priced that way to make them appear cheaper. Later we saw late votive candle holders on aluminum candleholders. Potential collectors will have to do their homework before they pay big prices.

Chapter One:
Acorn and Nut Designs

When the Pilgrims arrived, Native Americans were already using designs that were familiar to them, designs of things in the forest and fields around them. They are still used abundantly today because everyone recognizes them. Another reason for the choice of acorn and nut designs is the fact they are still impressive, especially when used on metals.

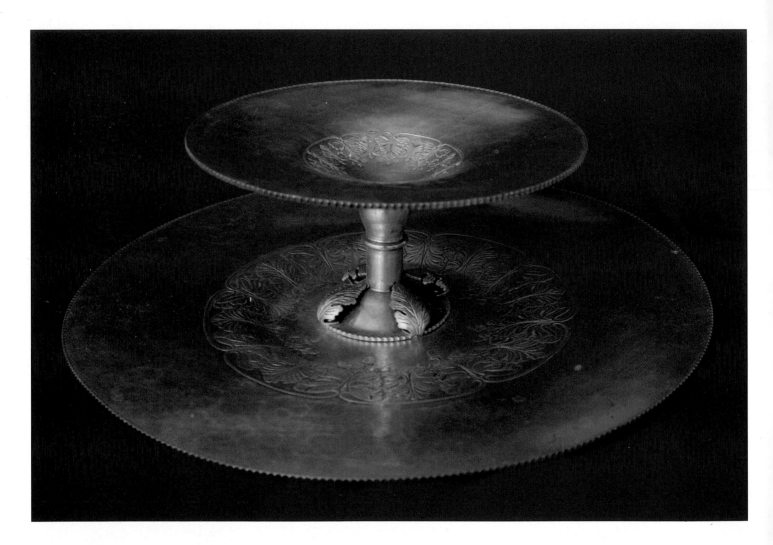

Tray, double serving, could loosely be called a tidbit tray. Continental Silver Company, Hand Wrought, Silverlook, 18 inches in diameter bottom, 10 inch top, Oak leaves and acorn design, scarce. $50-$60.

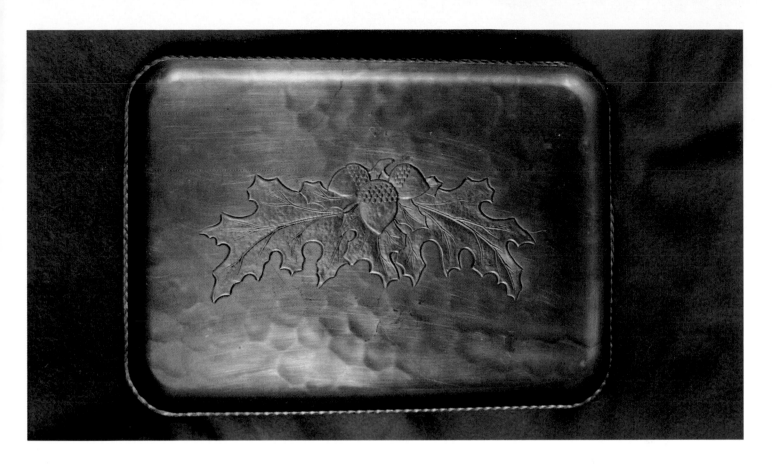

Tray, small, oblong, 7.5 by 10.5 inches, hand forged, Everlast trademark, heavy metal, $12-$15.

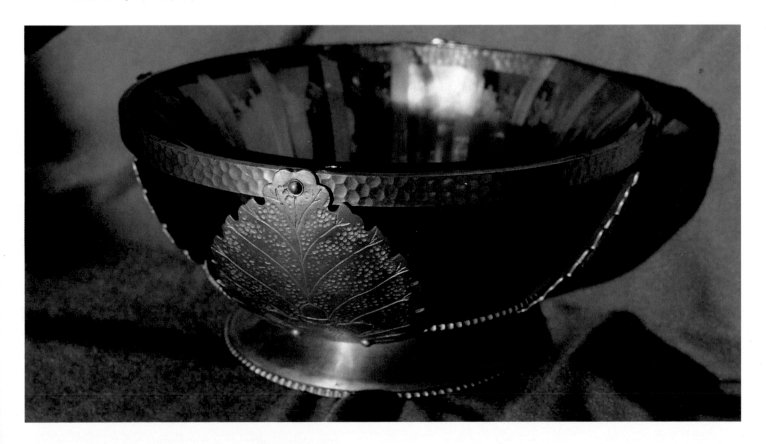

Acorn and leaf decorated aluminum holder for glass bowl. Original bowl was clear glass, color seems to give accent. Continental Silver Company, Hand Wrought, Silverlook trademark. With replacement bowl $35-$40, with original bowl $45-$50.

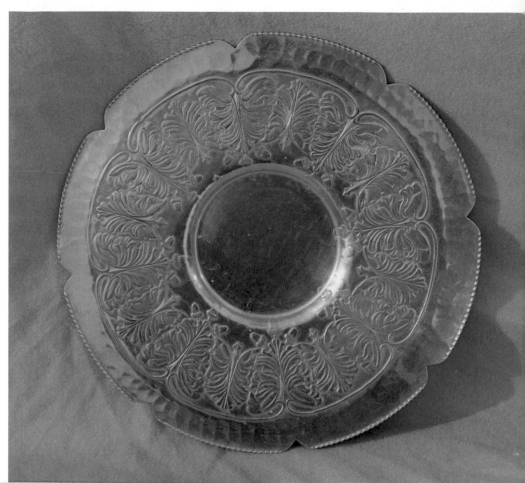

Pie Plate Holder, Continental Silver Company, Hand Wrought, Silverlook trademark, 10 inches diameter, $30-$35.

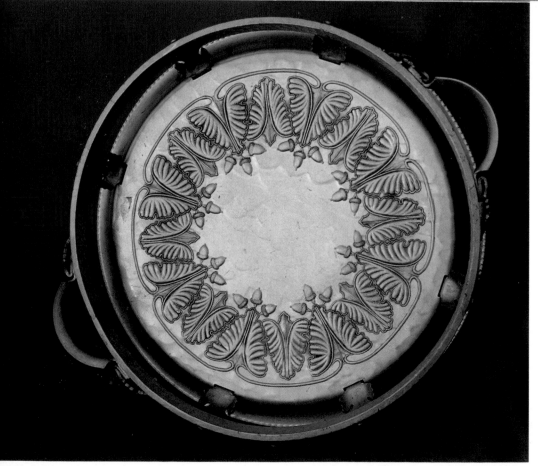

Round tray or plate, beautifully detailed design of acorns and leaves, 12 inches diameter. Continental, Hand Wrought, Silverlook trademark. $23-$29.

Chapter Two:
Ashtrays and Coasters

Bridge was probably the Number one card game during the Forties through the Sixties, but the popularity of canasta was rising fast. This meant that a large number of people were playing cards on small card tables most evenings and every weekend. Since most men and women were cigarette smokers, an ashtray was essential. A majority of them also liked a cool beverage during the evening. This meant a coaster was necessary as the moisture from the glass could and would cause dampness on the table. This in turn would harm the cards. The small aluminum ashtrays or coasters were the answer, as they were small and interchangeable. In some early catalogs they were first advertised as ashtrays and later as coasters. Depending on her guests, the hostess probably preferred the set of eight as that meant four could be used as ashtrays and four as coasters, and they all matched. Not everybody used their sets this way, but the majority of people we played with did.

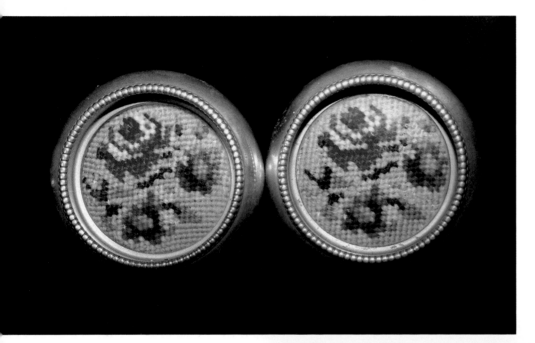

Coasters, aluminum, needlepoint under glass, Made in Hong Kong, $6-$8 each.

Coasters, embroidered center, base flips off allowing owner to change centers. Made in Hong Kong. $6-$8 each.

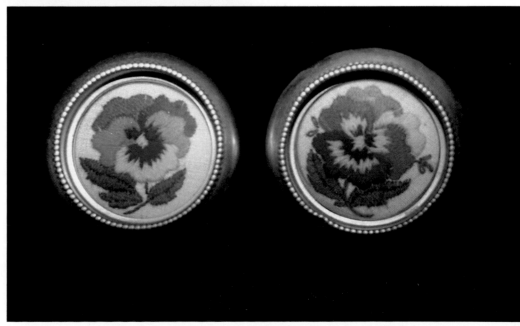

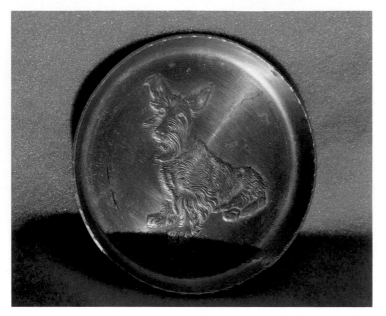

Coaster with Scottie dog design. Unmarked, not too plentiful nor too popular now. $3-$7 each.

Set of four coasters, also made in sets of eight. Hand Forged Everlast trademark, floral design. $15-$22 set.

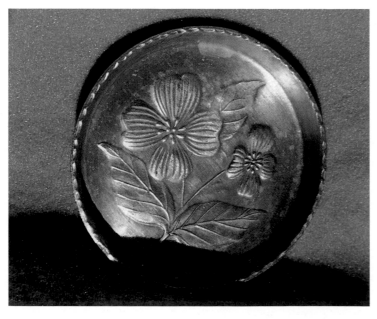

Coaster, floral design. Trademark a horse's head and Stede. Heavy aluminum. $6-$8 each.

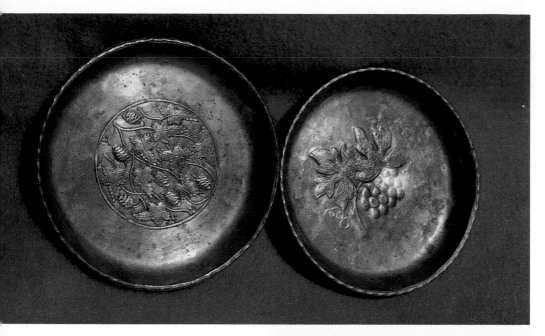

Coasters made by Everlast. Good aluminum and workmanship. $10-$12.

Coasters, hammered aluminum borders on glass, unmarked, plentiful. $5-$10 for set of four.

Pair of different sized coasters. Right has Kensington trademark $8-$10, Left, unmarked, $4-$6.

Chapter Three:
Baskets

Almost from the beginning of time, people have depended upon baskets for harvest, storage, and display. When aluminum became popular the trend continued. The manufacturers made fruit basket, candy baskets, and baskets for assorted uses. Some were made entirely of aluminum while others had a glass or china base. Even those can be divided into different categories, such as the china base which can be good china or the pottery type which was being made at that time. The glass bases can vary from pattern glass to a fine etched glass base. Aluminum baskets aren't as plentiful as some other pieces and prices will be a bit higher than for run-of-the-mill pieces.

Basket with twisted handle, 9 inches square, Everlast Hand Forged trademark. $18-$24.

Small, deep basket, unmarked, pottery inset from Southern Potteries, Erwin, Tennessee. $15-$20

Basket, 10 by 12 inch size, good quality aluminum, World Hand Forged trademark. $20-$25.

Basket, floral design, Hand Forged Everlast Metal trademark. $19-$27.

Basket with braided handle, good quality aluminum, acorn and leaf pattern by Continental Silver Company, has Silverlook trademark. $25-$35.

Basket with twisted handle, Everlast Hand Forged trademark. $20-$27.

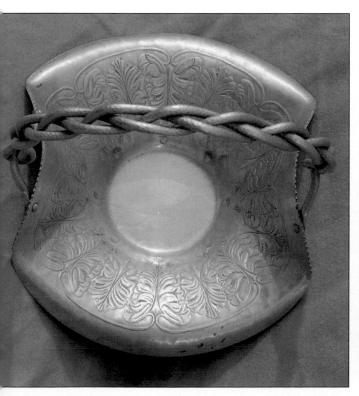

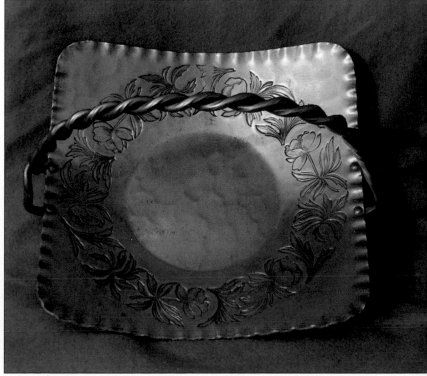

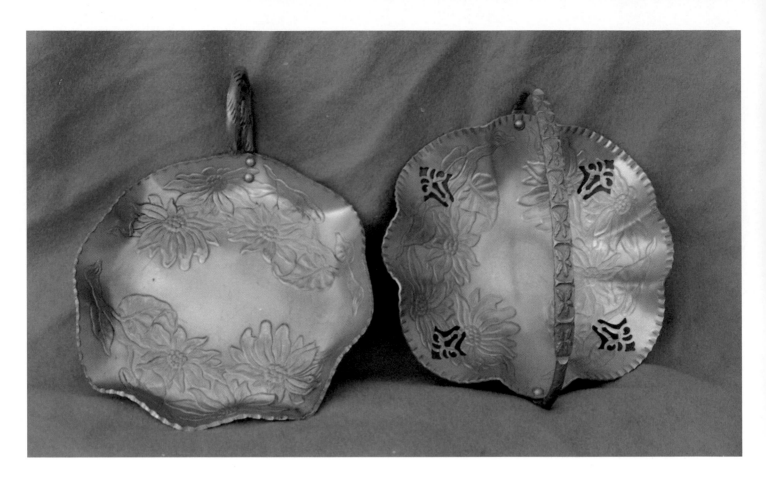

Basket and candy dish showing how the same pieces can be
made for different uses. Unmarked, but Farber and Shlevin made
pieces like these. Basket $15/$18; candy dish $12-$15.

Basket in perfect condition. Continental Silver Company, Inc.
trademark, Brilliantone and pattern name Wild Rose stamped on
back. $20-$30.

Basket, heavy aluminum, Everlast trademark. $23-$29.

Round basket in Wild Rose pattern, Continental Silver Company
trademark. $15-$20.

Basket with Indian Tree pottery base. Also made in candy dish. Aluminum unmarked, pottery base marked "A Product of Farber and Shlevin, Inc., Brooklyn, New York." $18-$25.

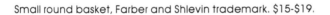

Small round basket, Farber and Shlevin trademark. $15-$19.

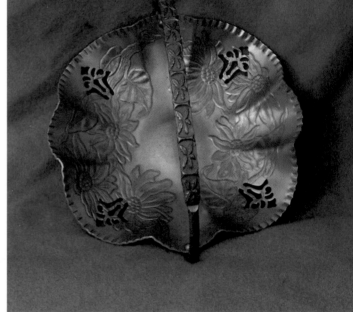

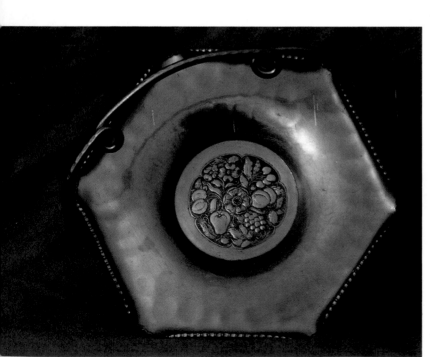

Basket, small but impressive design of fruit and flowers, Cromwell Hand Wrought Aluminum trademark. $15-$19.

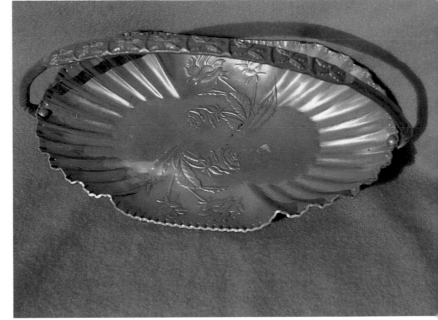

Oblong basket, Farber and Shlevin, Inc., trademark. $17-$23.

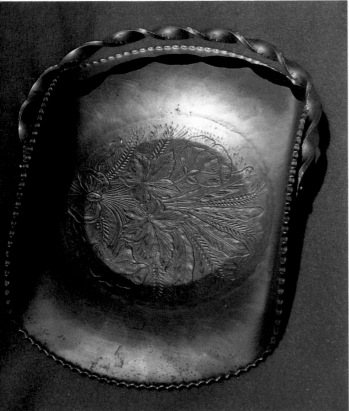

Basket with sides pulled up, Cromwell Hand Wrought Aluminum trademark. $14-$17.

Basket with pattern glass base, aluminum border and handle, unmarked. $16/$20.

Chapter Four:
Berry Designs

A degree in botany would be most helpful for all antiques and collectibles researchers, however few have it. Identification of flowers seems so much easier perhaps because shapes and sizes are more realistic. Berries are berries and so many of them are too small to really show the design, if it has one. But berries are very attractive and have been used to decorate china, glass, and aluminum.

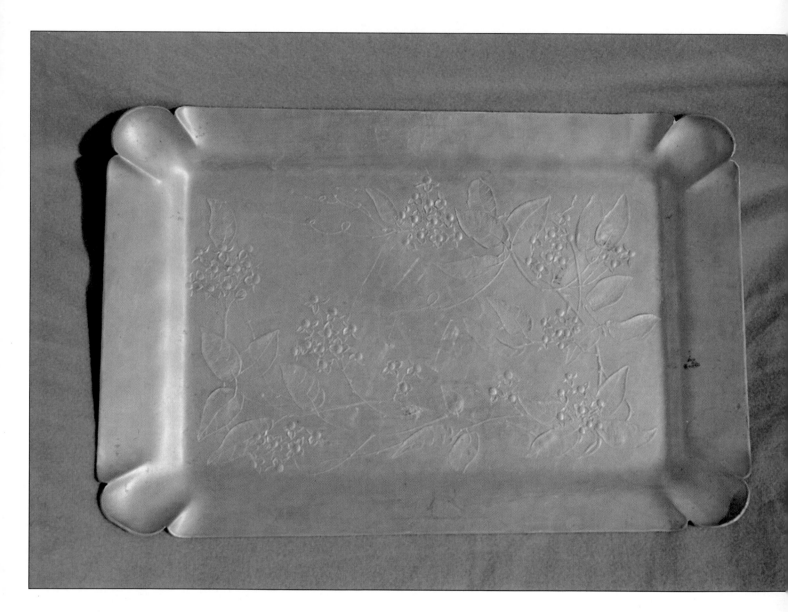

Tray, bittersweet decoration, 12 by 18 inches, Wendell August Forge trademark. $50-$60.

Handled dish, light weight, unmarked. $13-$16.

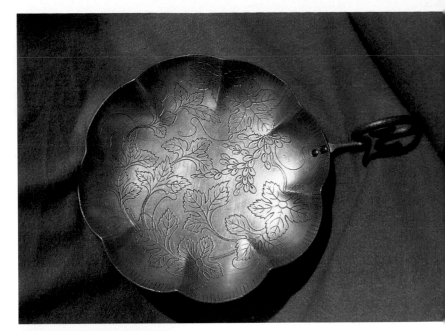

Tray, excellent workmanship, Everlast trademark. $18-$24.

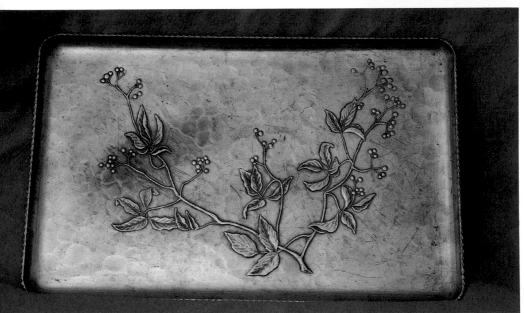

Handled tray, grape design, Hammercraft Hand Hammered trademark. $14-$19.

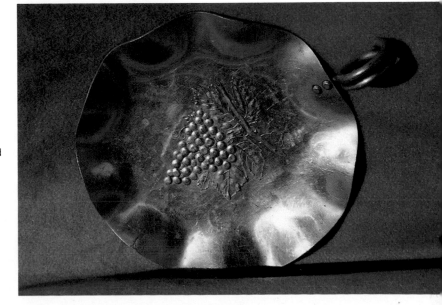

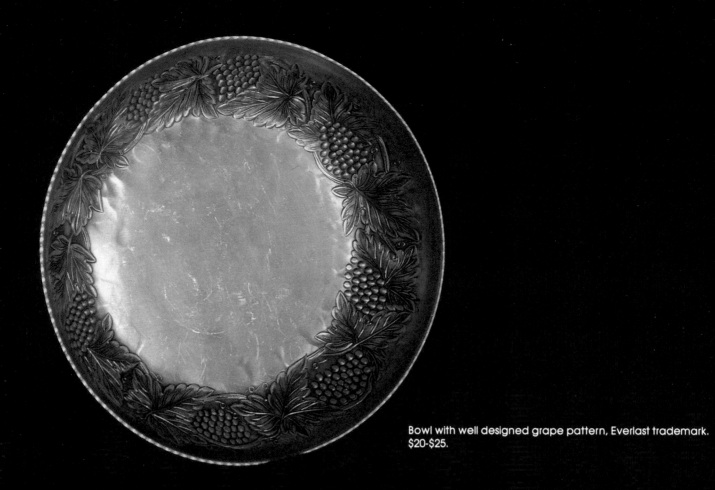

Bowl with well designed grape pattern, Everlast trademark. $20-$25.

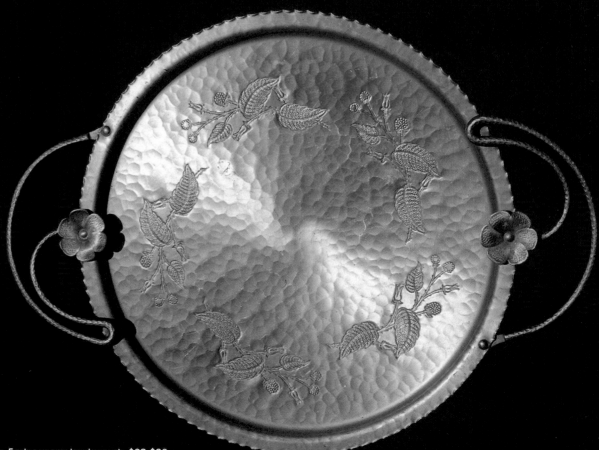

Large tray, fancy handles, Farberware trademark. $20-$28.

Chapter Five:
Beverage Sets

During the Victorian era, home entertaining was universal. In the first place, there just weren't that many places to take one's guests, especially in the smaller towns. And in the second place families were so large it would have been quite expensive to take guests out to eat, or even for refreshments. Therefore, both family and friends were entertained at home. Lemonade seemed to be the beverage of choice, and for that they needed pitchers, tumblers, and tray on which to carry the pitchers and tumblers. Remnants of that custom were still around when aluminum giftware began its first rise in popularity, so naturally the makers continued to make beverage sets. Aluminum had a big advantage over the glass sets used previously as it didn't break when dropped. It might dent, but dents could easily be smoothed out. Complete beverage sets, the pitcher, tray, and 6 to 8 matching tumblers are among the more expensive pieces in aluminum today. Yet it is still possible to find single tumblers priced as low as $3 to $4 each, and less at yard sales. For that reason collectors should acquaint themselves with the various makers and their patterns or designs as it is rather easy to assemble a beverage set for much less money than that asked for a completed set.

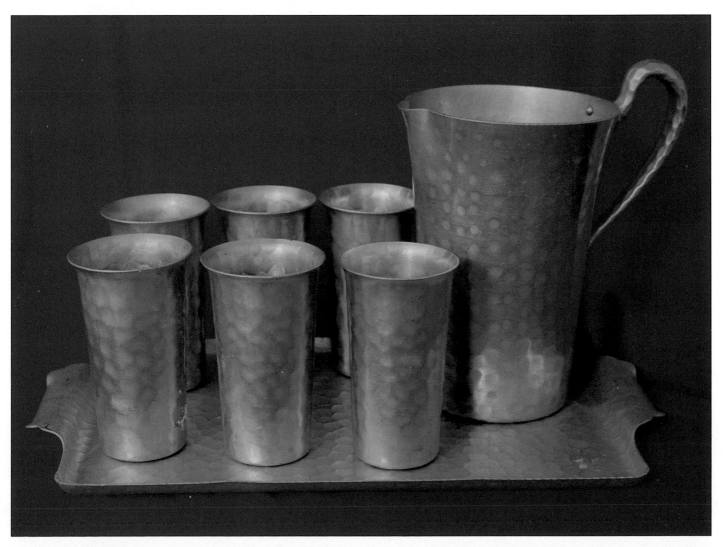

Beverage set consisting of six tumblers, pitcher, and matching tray. Sets are expensive and hard to find. Everlast trademark, good quality aluminum. $150-$175.

Large tumblers, can sometimes be found and eventually become a set. $8-$12 each.

Anodized beverage set in basket carrier, both from the Fifties. Anodized pieces are not as expensive as the older aluminum. Pitcher is unmarked, tumblers have Perma Hues, Edgerton, Ohio trademarks. $95-$125.

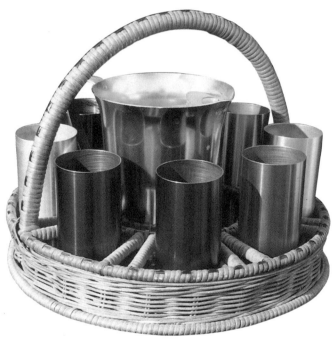

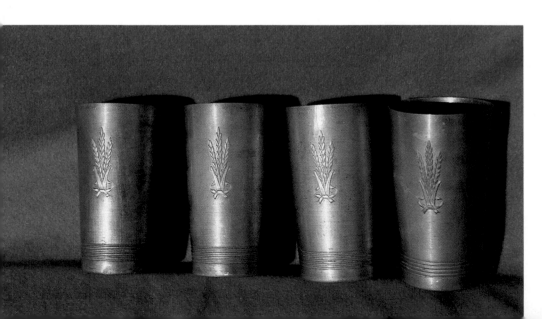

Tumbler, medium size, medium weight aluminum, Product of West Bend Aluminum Company, West Bend, Wisconsin trademark. $7-$9 each.

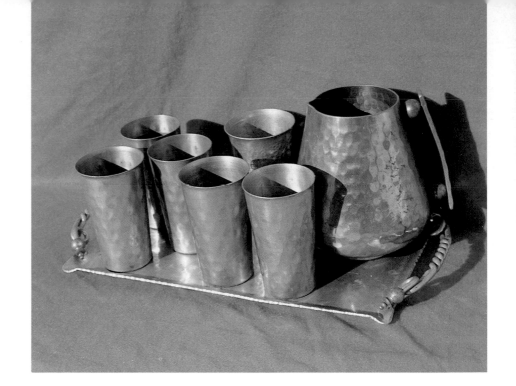

Beverage set complete. Set bought at an estate sale ten years ago. Pitcher and tumblers were sold from the kitchen, tray was with cheaper things in the barn. Buenilum trademark. $250-$300.

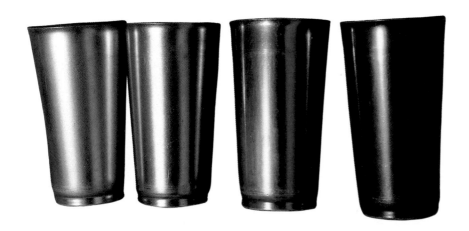

Set of four anodized tumblers, late, unmarked. $12-$15 set.

Beverage set, pitcher of eight tumblers. Buenilum trademark. $195-$225, with matching tray $250-$300.

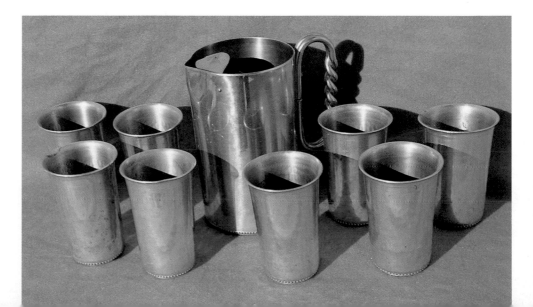

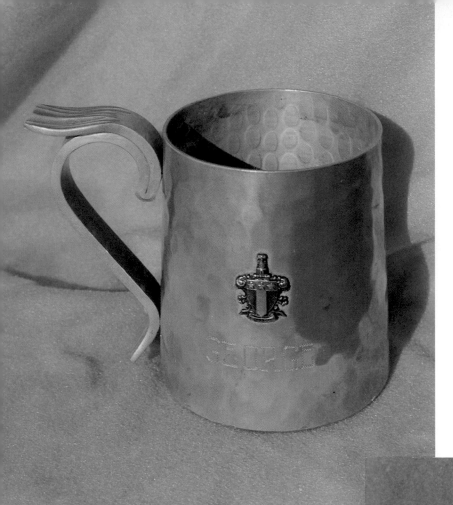

Monogrammed mug. What appears to be coat-of-arms over the name George. Buenilum trademark. Scarce. $20-$25.

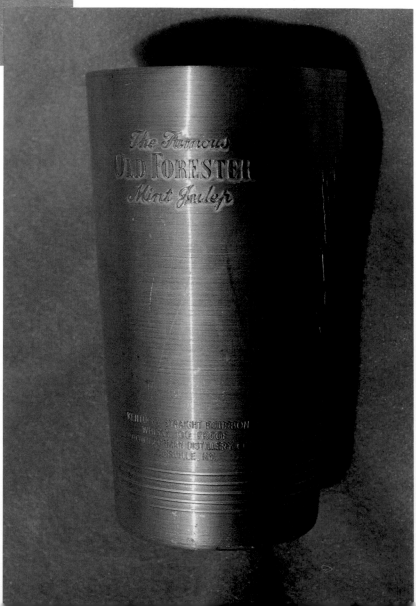

Advertising tumbler. Three sprigs of hops decorate either side along with The Famous Old Forester Mint Julep in raised letters. Stamped near the bottom is Kentucky Straight Bourbon Whiskey 100 proof, Brown-Forman Distillery, Company, Louisville, Kentucky. Made by West Bend Aluminum Company, West Bend, Wisconsin. Advertising collectors will love it, others will not. $12-$15.

Tumbler, bright cutting, unmarked. $9-$12 each.

Pitcher, Buenilum trademark. $40-$50.

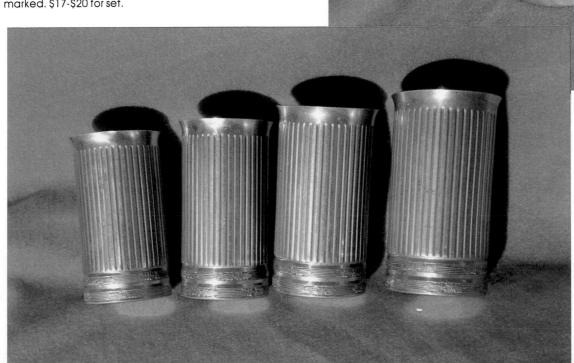

Set of four light weight tumblers, un-marked. $17-$20 for set.

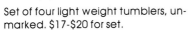

Chapter Six:
Bird and Fowl Designs

It has long been the custom of people who design and make things with their hands to use familiar things, usually things they see every day. Their surroundings also have a bearing on these familiar things. For example, the Native Americans of the South and Southwest were more apt to use rattlesnakes in their designs than were the Northern tribes. By the same token the northern tribes were more apt to use snow scenes than their southern cousins. This trend continued with the Colonists. But there were some things, such as birds and fowls, that were known in all areas due to the fact that so many of them migrated from one area to another at different seasons of the year. For that reason these craftsmen not only whittled replicas of the birds and fowls, but used the designs often on various things they made. Aluminum giftware was no exception. The turkey platters made by Wendell August Forge are one of the most sought after, while some of the cheaply-made, unmarked bird decorated coasters and canapes are the least desirable and the least expensive.

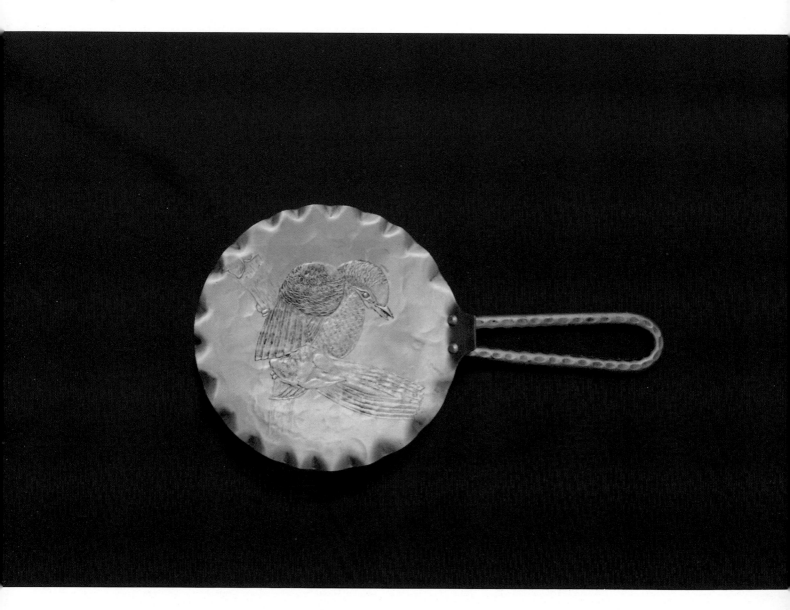

Silent butler, bird design, N. S. Co., Hand Hammered trademark.
$19-$25.

Plate, light as aluminum but probably mixed with an alloy. Oscar
B. Bach, Sterling Bronze Co., New York trademark. $25-$30.

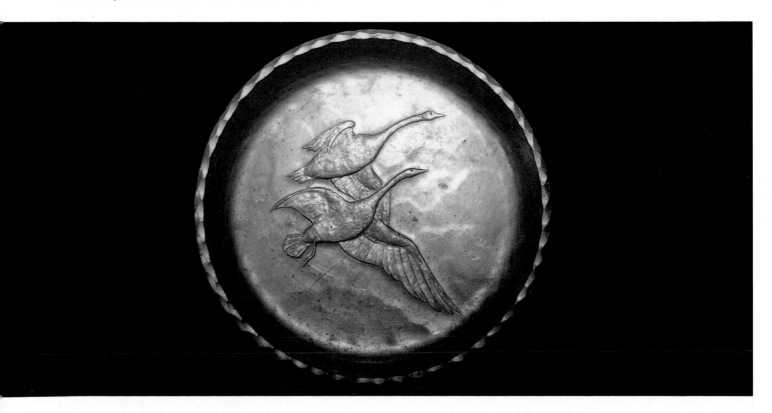

Coaster, heavy aluminum, A (Arthur Armour) trademark. $16-$23.

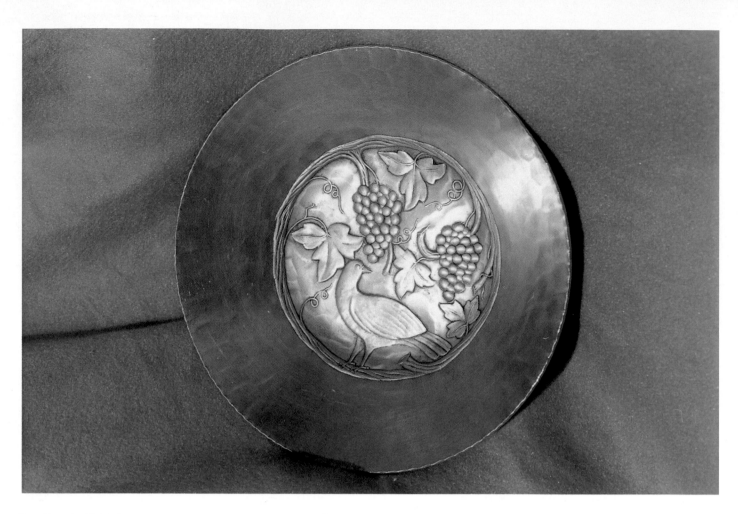

Small bowl with bird and grape design, Everlast trademark. $20-$25.

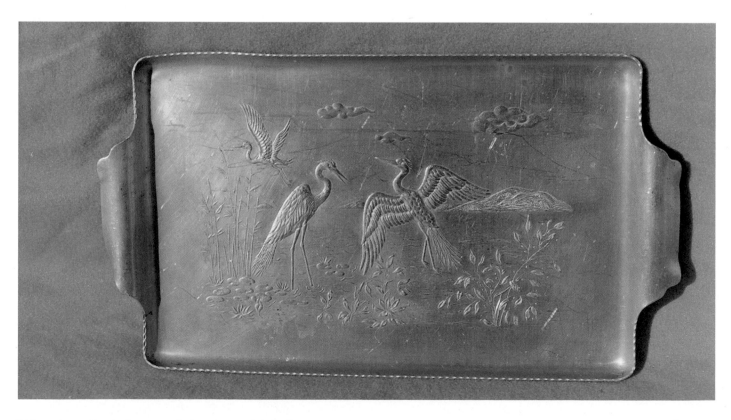

Oblong tray with what appears to be cranes, Admiration
Products Co., New York, NY trademark, heavy aluminum. $17-$26.

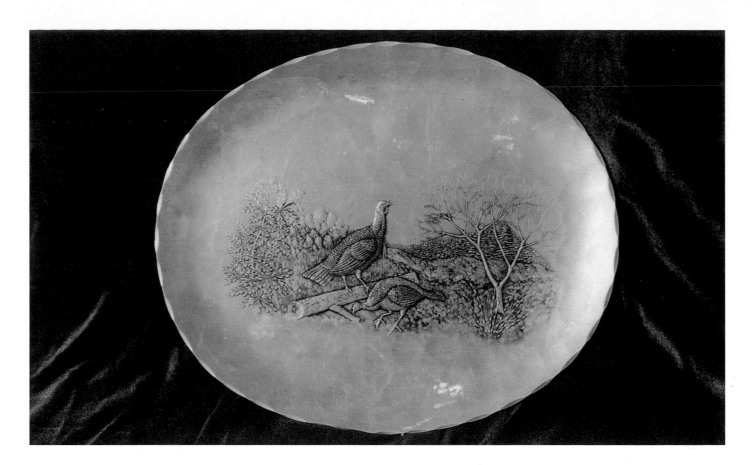

Platter with turkey design, heavy aluminum, excellent workmanship, Wendell August Forge trademark with additional information Hand Made for the Employees' Life 1969 Court of Honor. $85-$95.

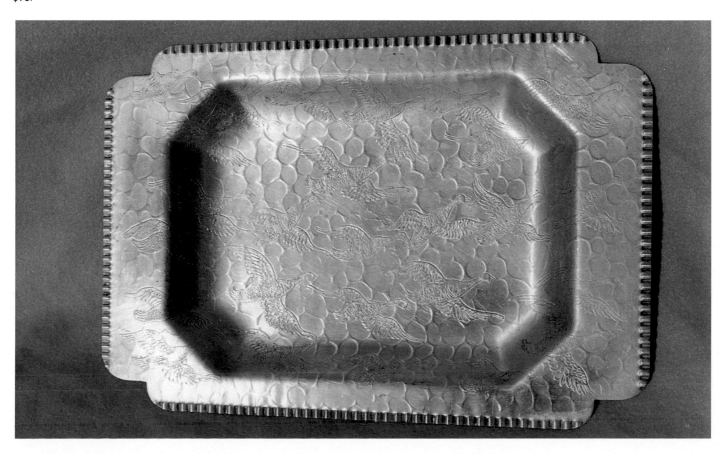

Tray with birds, Designed Aluminum trademark. $14-$18.

Chapter Seven:
Bowls

There is no explanation for the large number of bowls made in aluminum giftware except that like the china and glass bowls they were also needed for serving when entertaining. It is an established fact that they were and still are very attractive as decoration and they are very useful as fruit and vegetable bowls. They are known to have been used for serving salads or punch, or they could be used for soups or relishes. They were made in a variety of shapes an styles, and are still plentiful.

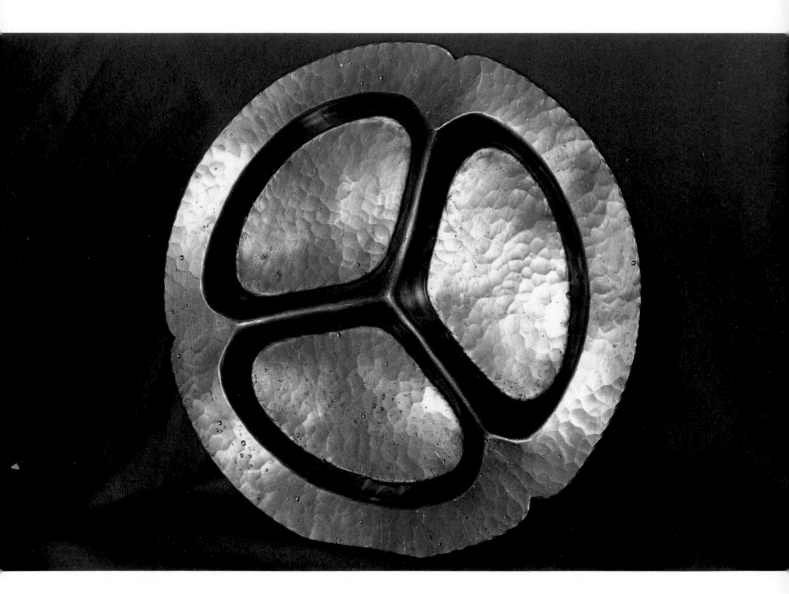

Three sectioned bowl, marked Hand Made, Malcolm Bunker, Lexington, Mass. $15-$19.

Bowl, Canterbury trademark. $16-$20.

Bowl, 8.5 inches in diameter, good workmanship, Everlast trademark. $13-18.

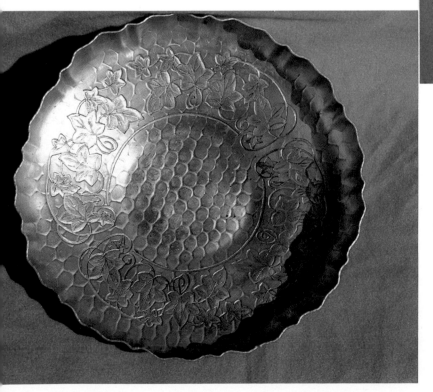

Bowl, World Hand Forged trademark. $18-$26.

Large bowl, Everlast trademark. $19-$27

Small bowl, light weight, unmarked. $10-$14.

Bowl, Canterbury trademark. $20-25.

Bowl, plain except for ribbed base, Continental Silver Co. Corduroy trademark. $15-$19.

Bowl, Farberware trademark. $15-$20.

Bowl, small and deep, World Hand Forged trademark. $16-$24.

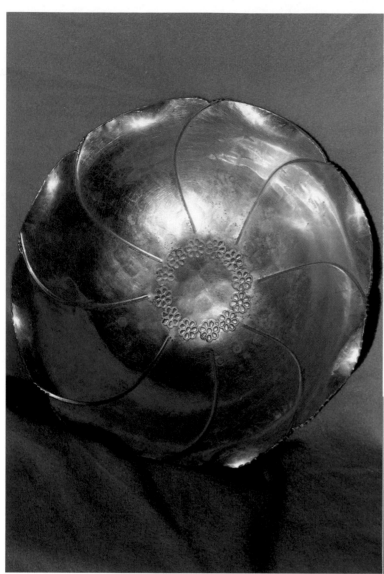

Bowl, 14 inches diameter, Buenilum trademark. $20-$25.

Bowl, heavy aluminum, Palmer-Smith trademark. $18-$24.

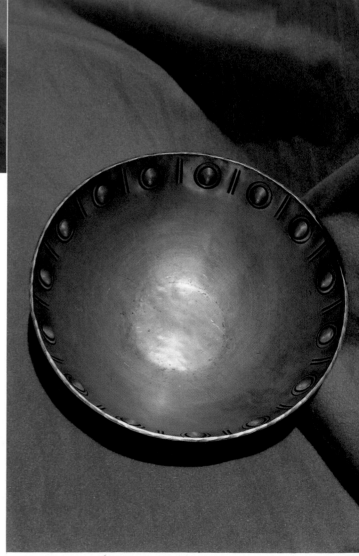

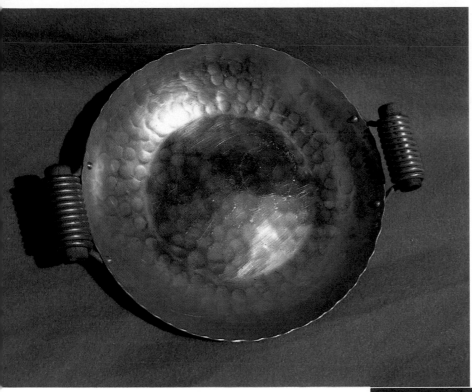

Bowl, 16 inches diameter, rose decoration, unmarked. $25-30.

Bowl, wooden handles wrapped in aluminum, Buenilum trademark. $12-$15.

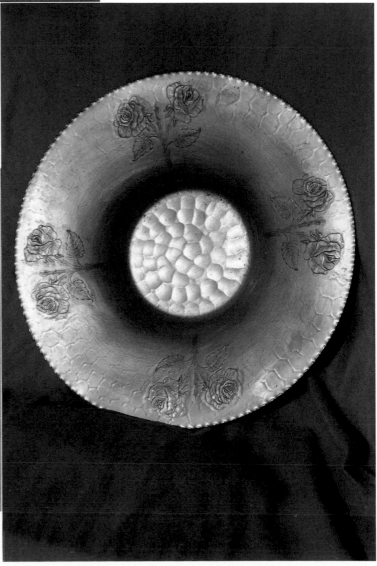

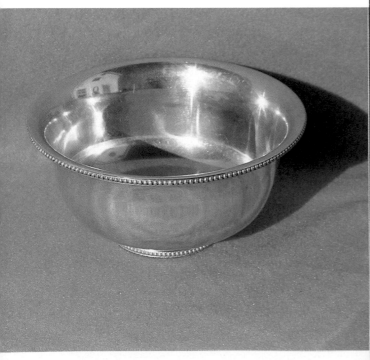

Bowl, plain, 6.5 inches diameter, could pass for silver. Buenilum trademark. $12-$16

Chapter Eight:
Bread, Rolls, or Celery Trays

Bread has long been considered essential in our diets. During the time aluminum giftware was being made, the majority of women were not working outside the home. They were homemakers who still baked bread and rolls for their families. To serve the homemade bread and rolls a bread tray was necessary. The women had long had silver, glass, and plated trays, but the new aluminum replaced most of these, probably due to the fact that the aluminum was new and they were tired of the old ones. Many were gifts so they wanted to use them. Whatever the reason, the new bread trays were used daily. Some were made originally for celery, but somewhere in the scheme of things they became interchangeable.

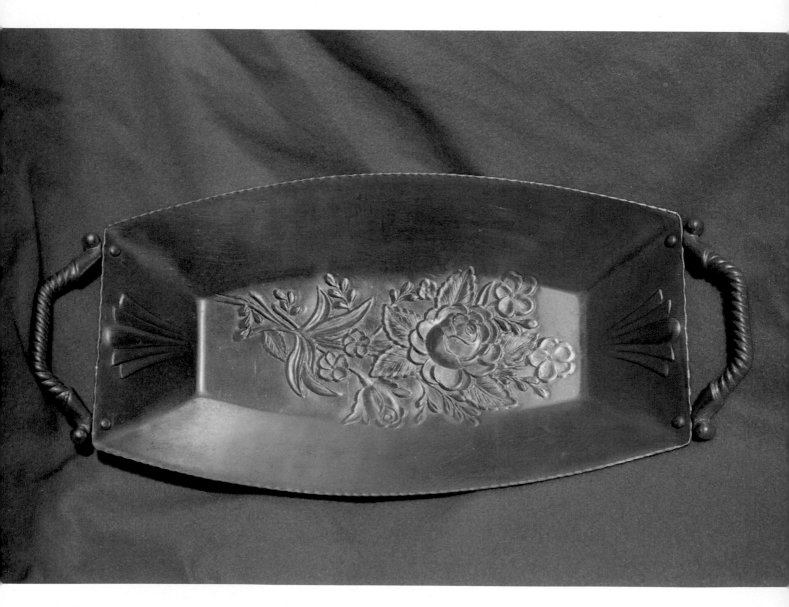

Bread tray, heavy aluminum. $15-$20.

Bread tray, leaf shaped, Everlast trade-mark. $15-$19.

Bread tray, Everlast trademark. $12-$17.

Bread tray, Anchorware Aluminum trademark. $12-$15.

Bread tray, floral design. $12-$15.

Bread tray, Forman Family trademark. $12-15.

Bread tray, heavy aluminum, Everlast trademark. $16-$22.

Chapter Nine:
Buenilum Pieces

Aluminum giftware probably got its name from the fact that it just lends itself to gift giving. And no company's work is more desirable than Buenilum. It is plain, in most cases, and on the pieces where a design is used, it is usually a small one. For that reason it is about as popular today as when it was made. It can still pass for silver, at least the "Poor Man's Silver." A lady who lived in East Norwalk, Connecticut, as a bride says it was the most popular wedding gift at that time, probably because the forge was located there. She recently passed on some of her Buenilum wedding gifts to a woman who didn't receive any as wedding gifts. The recipient has since passed on some of the pieces to a young bride proving that old aluminum continues to be a choice gift.

Buenilum was the name or trademark used by the firm of Buehner Warner who used more than one logo on their pieces. But the one most often found today has a design of what appears to be a tall, narrow tower with the letter B on one side and a W on the other. The name Buenilum is underneath followed by Made in U.S.A.

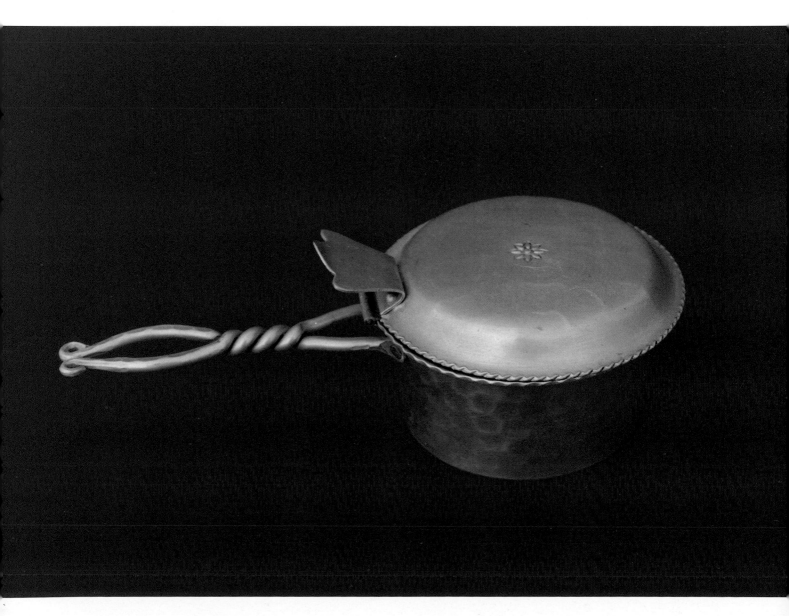

Silent butler, deep, Buenilum mark. $20-$24.

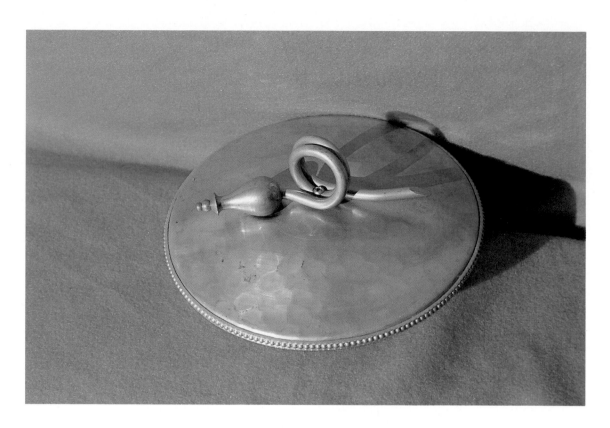

Small casserole, Buenilum trademark. $15-$19.

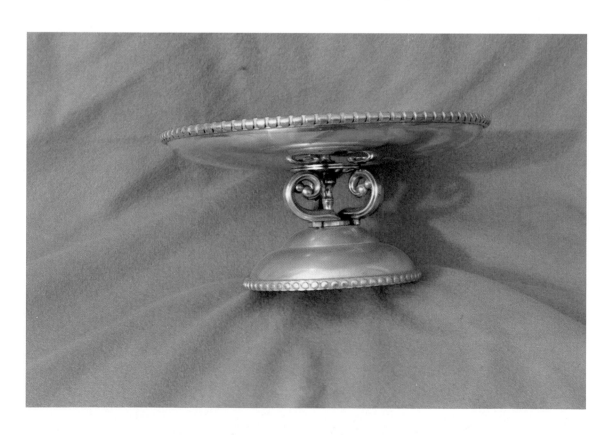

Compote, deep, Buenilum mark. $18-$23.

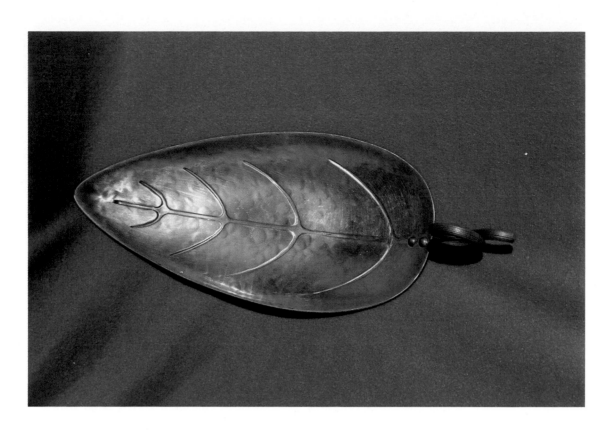

Cracker tray, Buelinum mark. $19-$24

Leaf-shaped dish, handle, Buelinum trademark. $12-16.

Chapter Ten:
Butter Dishes

When aluminum giftware was being made butter was still considered a necessity — on the table every meal, therefore butter dishes were essential. Most of the butter dishes had a glass container that fit inside the dish to protect the butter from the metal. Several types of butter dishes were made, the small size that would hold one stick and the larger one that probably held a pound. Buenilum is the only forge known to have made round butter dishes. They were made to fit the butter molded in the round, wooden butter molds.

Butter dish with matching aluminum butter knife. $25-$30.

Butter dish, glass liner, unmarked. $19-$24 complete.

Inside of butter dish showing glass liner.

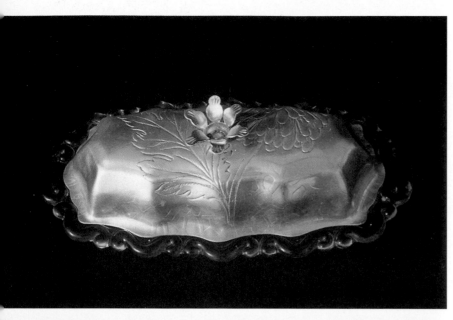

Butter dish with glass bottom, unmarked but Forman Family pattern. $18-$23.

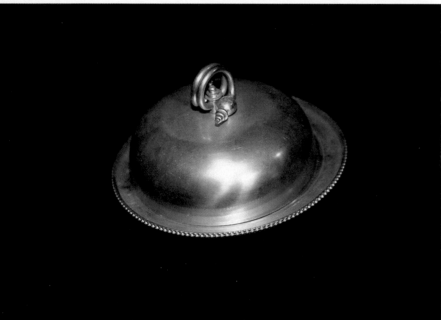

Round butter dish with glass liner, Buelinum trademark. $22-$30.

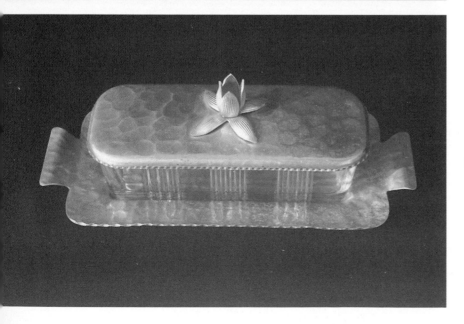

Butter dish, unmarked. $17-$23.

Chapter Eleven:
Candleholders
and Hurricane Lamps

Although most of the country was well supplied with electricity by the time most aluminum giftware hit the market, there were still those who preferred to dine by candle light. It was believed to have been done partly because of the custom established by our ancestors who didn't have electricity and partly it was done to create a romantic atmosphere. Side-boards were very popular then, and nothing "dressed them up" like a pair of hurricane lamps with a matching bowl. They also made excellent gifts for new brides. Apparently they were very popular as many styles and shapes have been found.

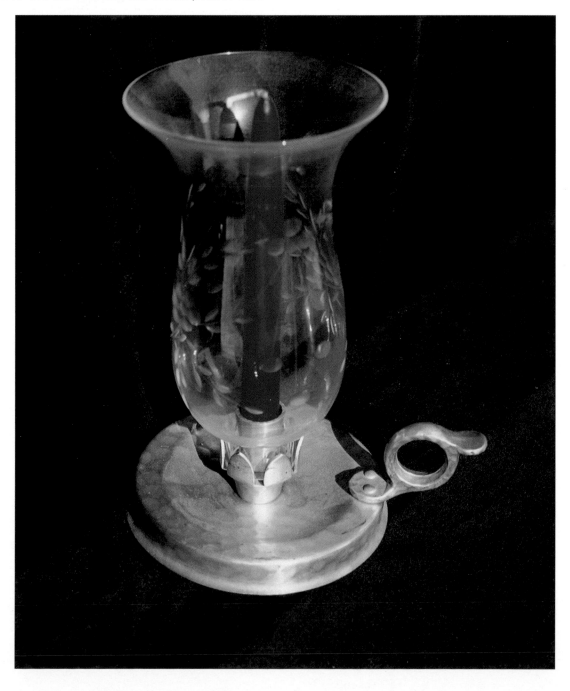

Hurricane lamp, single, unmarked. $25-$35.

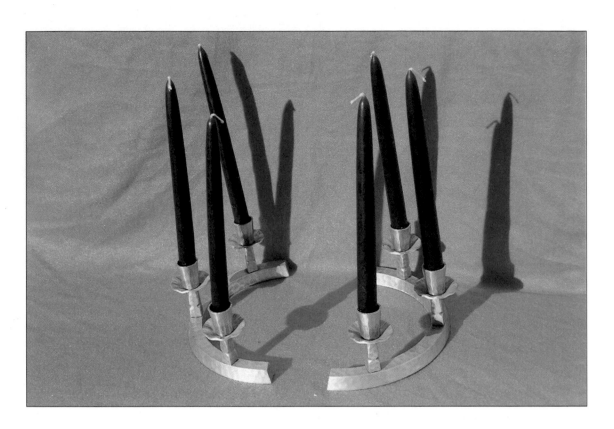

Pair of candleholders, part of a set. Originally a bowl was made
to fit into the center, unmarked, $75-$100.

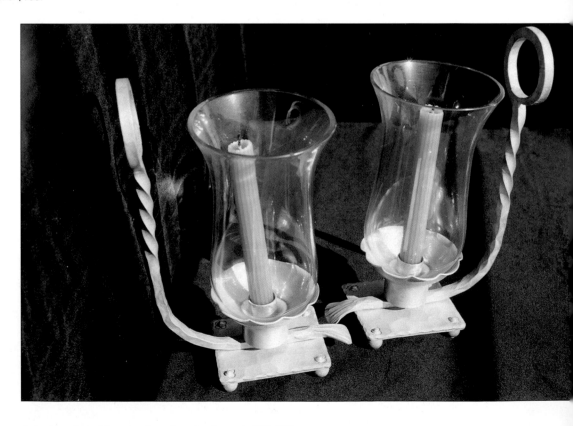

Pair of hurricane lamps, Buenilum trademark. $75-$85.

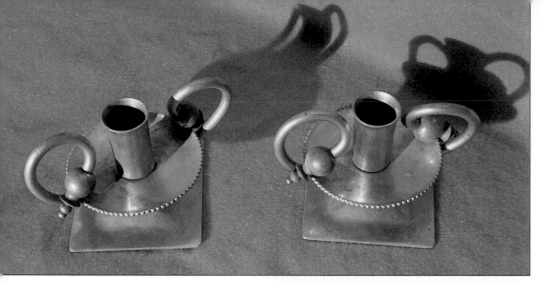

Pair of candleholders, good quality, Buelinum trademark. $18-$27.

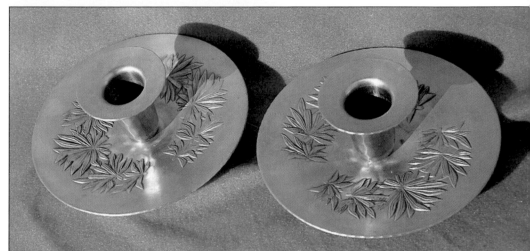

Pair of candleholders, Everlast trademark, one has double trademark stamp. $25-$35.

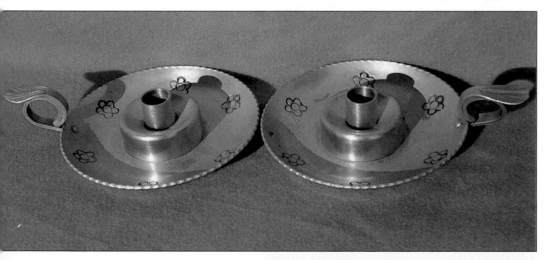

Pair candleholders, Forged Aluminum Intaglio Design, E.M.P.C. trademark. $20-$25.

Pair of low candleholders, quite plain, good quality aluminum, Buelinum trademark. $25-$30 pair.

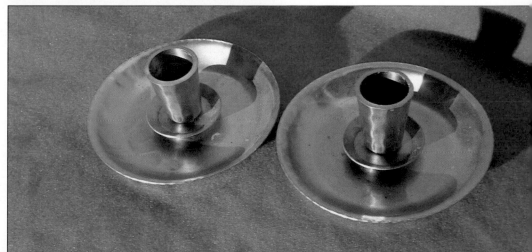

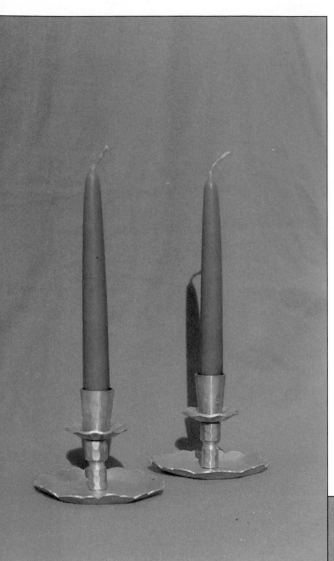

Pair of candleholders, good quality
aluminum, Everlast trademark. $18-$24.

Pair of candleholders, light weight
aluminum, unmarked. $18-$24.

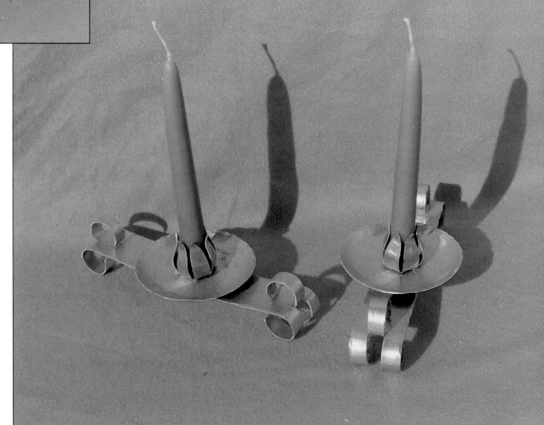

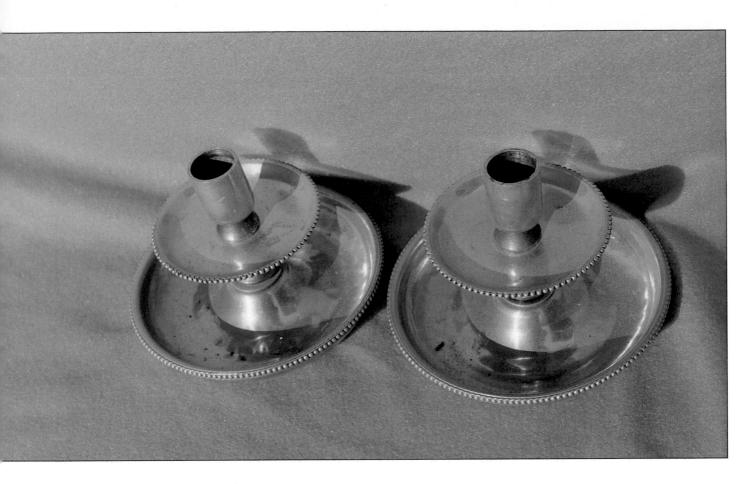

Pair of candleholders, unmarked. $19-$25

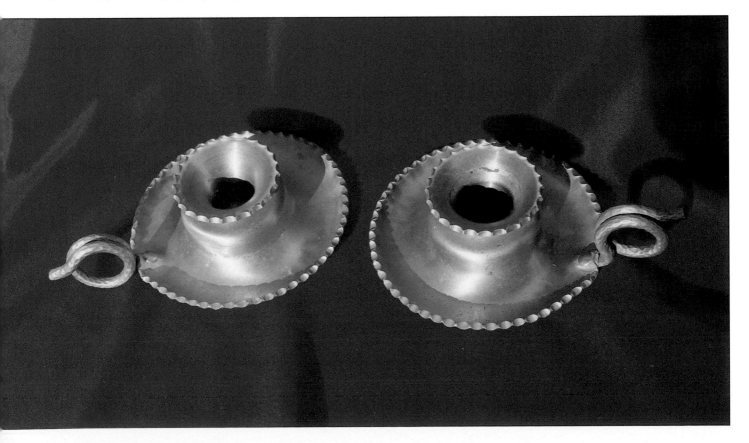

Pair of low candleholders, good aluminum, Farberware trademark. $23-$28.

Chapter Twelve:
Casseroles

Casseroles in either silver, plate, or aluminum were and still are a favorite of the homemaker who entertains or has rather large family meals. The food can be served at the table in the casserole which is actually an attractive container for the Pyrex or other type bowl in which the food has been cooked. Or the cooked food can be transferred to a bowl which will fit the casserole after it has been cooked in another pot. Since aluminum was replacing silver pieces in some households, it was only natural it would be made in many sizes and shapes, apparently to please even the most discriminating homemaker. The metal casseroles helped to keep the food warm. Then there were the annual or semi-annual church meals, the so-called "dinner on the grounds." Parishioners leaving home early in the morning used casseroles often and in large numbers in an effort to keep the food warm until lunch time.

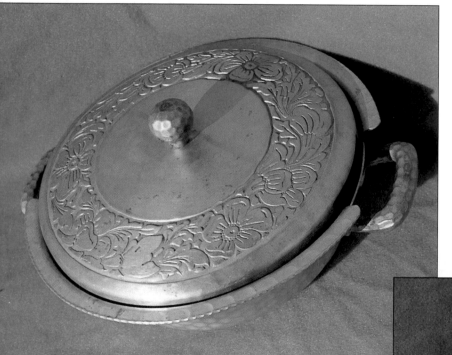

Casserole, 10.5 inches diameter, Everlast trademark, no liner. $27-$35.

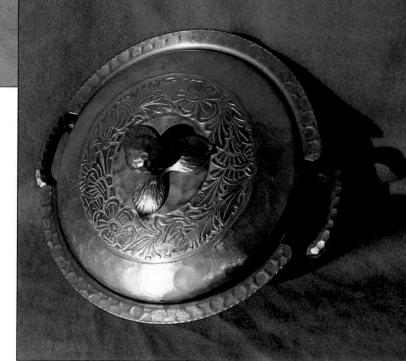

Casserole same as above but with different decorations around finial, 9 inches diameter, no liner. $24-$32.

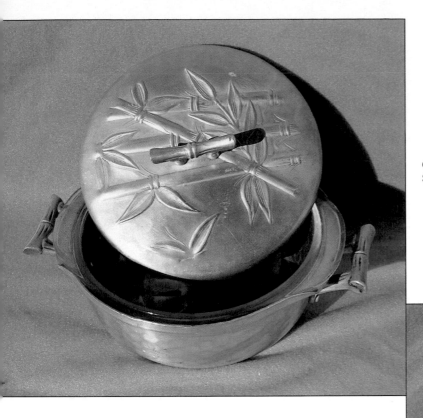

Casserole, Bamboo design, with glass liner, Everlast trademark. $29-37.

Casserole, without glass liner, Buenilum trademark. $24-$35.

Casserole, without liner, Everlast trademark. $25-35.

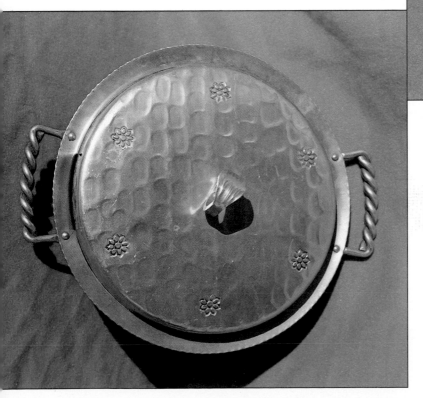

Chapter Thirteen:
Chafing Dishes

Long a favorite of the homemaker who enjoyed preparing some dishes at the table, or for those who liked a method of keeping other dishes bubbling hot, it was only natural the makers of aluminum giftware would make chafing dishes. They were so popular that they were not only made in American but in Spain, France, and England as well. Recently one was seen with an Italian trademark and country of origin. They seem to be growing in popularity again with the collectible ones increasing in price rather rapidly. There was a time, not too long ago, when an aluminum or even brass or copper chafing dish could be bought for $5 or $6. A couple of weeks ago an aluminum one was seen in a ski resort town priced $38.

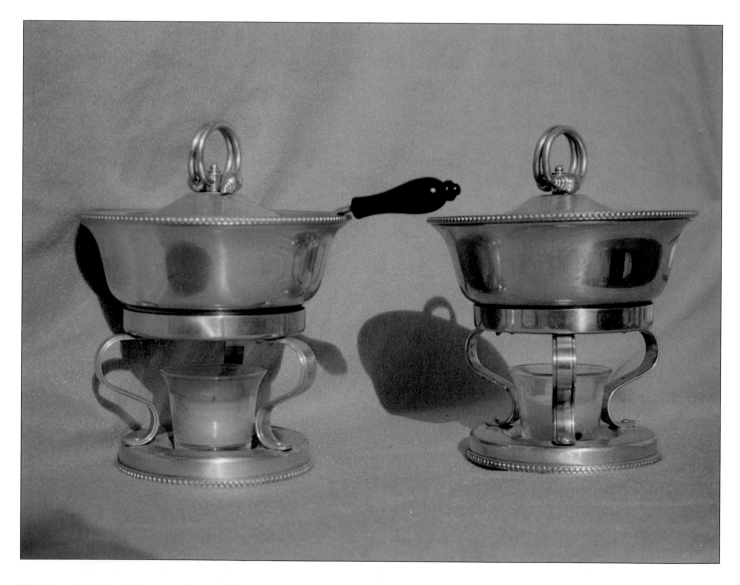

Pair of small chafing dishes, may be used for fondue, Buelinum trademark. $50-$60 for the pair.

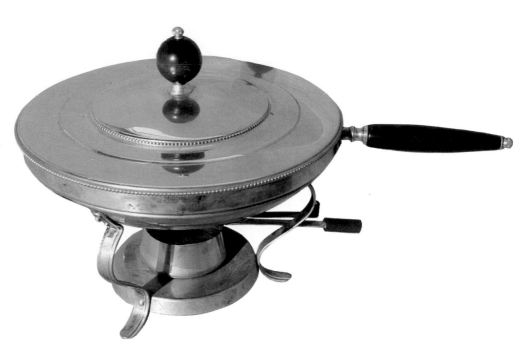

Casserole, 10.5 inches diameter, Everlast trademark, no liner. $27-$35.

Chafing dish, light weight, unmarked. $20-$28.

Chafing dish, unmarked. $35-$50.

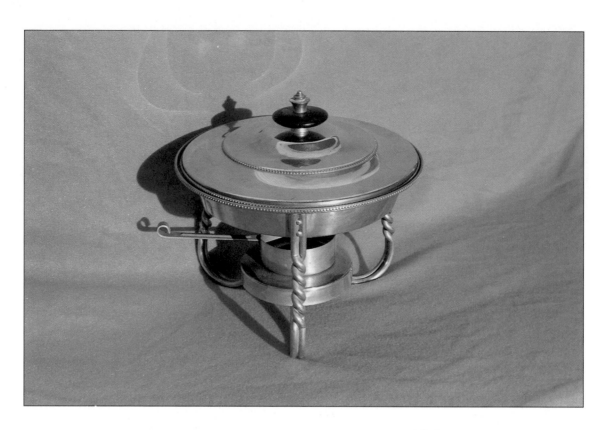

Chafing dish, wooden finial, Buenilum trademark. $30-$35.

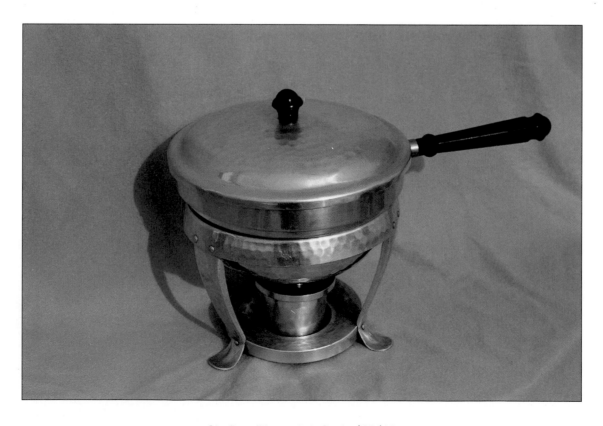

Chafing dish, made in Spain. $25-$30.

Chapter Fourteen:
Children's Playthings

Until a few decades ago boys were given replicas of farm or factory tool toys while the girls received homemaking toys. The reason for this was the fact that boys would usually become the breadwinners and the girls would become homemakers. Until a few decades ago, it seemed that a girl's chance of a good marriage, her only chance of escaping spinsterhood, was becoming a good housekeeper. To help the process along, young girls were given small replicas of all their mother's tools and utensils including teasets. They had tea parties with their dolls and siblings which helped teach them the correct way to entertain. At first they had tea sets made of china, often as good as that used by their mothers. Then there was the cheap china tea sets for those who couldn't afford the good ones. Apparently the breakage in the china sets made the tin and aluminum sets more attractive when they appeared in the Twenties and Thirties, especially to cost conscious parents. They were very inexpensive, a feature which, we believe, led to the destruction of the majority of them. They were so cheap, 5 and 10 cents each, mothers didn't want to give them space after the children were grown. It has been interesting to watch how many partial aluminum tea sets have surfaced since aluminum started its climb back to popularity. It seems the most sought after of the aluminum toys are the ABC plates and those with nursery rhymes. A child's stripped aluminum wagon was seen priced at $58.

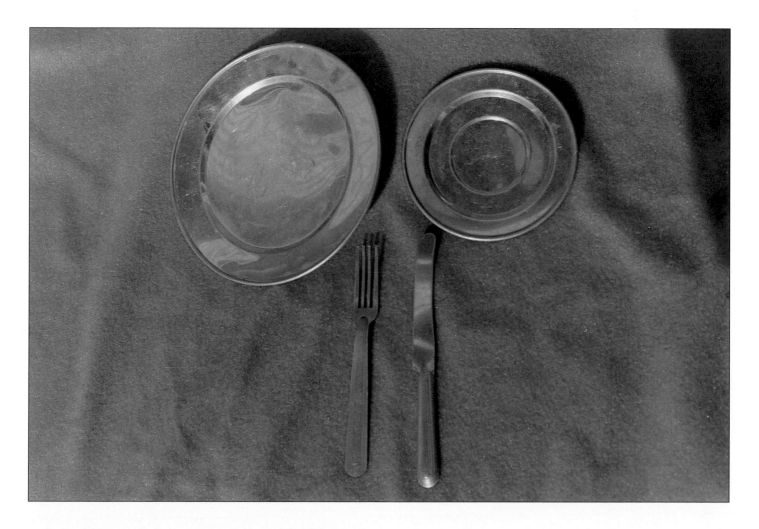

Place setting from child's aluminum tea set. Inexpensive and well liked by parents because they were unbreakable. Unmarked and thin aluminum. $35-$50 for set of four place settings.

Miniature candelabra. Even in the playhouse children were taught to play the hostess graciously. Unmarked. $15-$20.

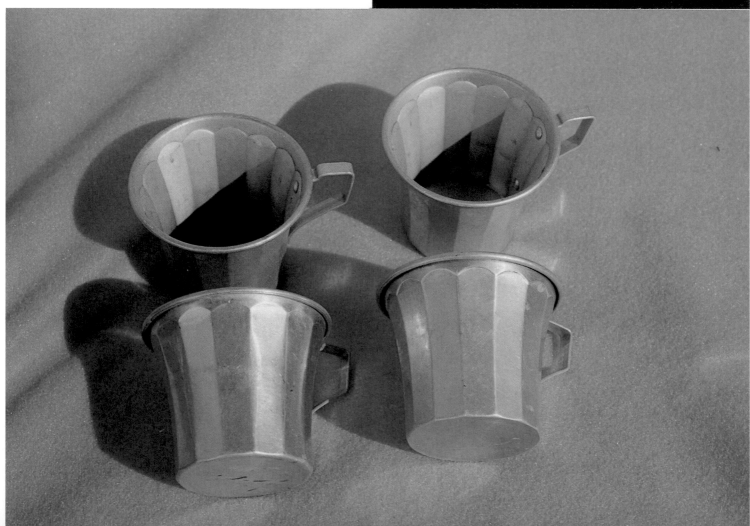

Set of four aluminum cups. Average size for children, unmarked. Set of four $20-$30.

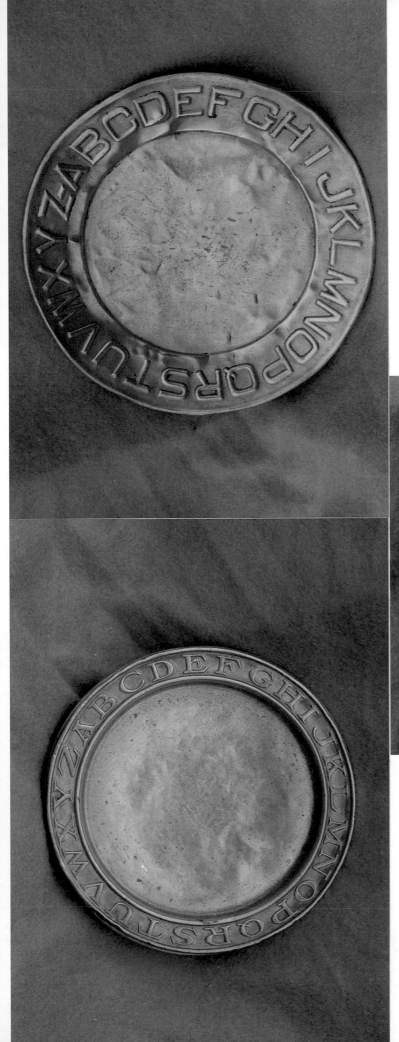

Aluminum ABC plate with large letters.
Children were taught the alphabet as
they ate their meals. Unmarked. $24-$28.

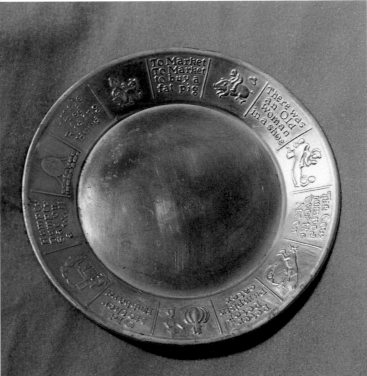

Nursery Rhyme aluminum plate. Children
were familiar with nursery rhymes so this
encouraged them to eat and learn.
Unmarked. $20-$30.

ABC plate with smaller letters, unmarked.
$22-$27.

Chapter Fifteen:
China and Glass Inserts

The only aluminum pieces with china insets that have been found so far were made either by Farberware, the trade name used by S. W. Farber or Farber and Shlevin. The majority of the pieces have a floral or berry design on the aluminum border, but one has been seen with mixed fruit. They made bowls, baskets, plates, and trays using a china center. The designs used most often on these pieces are a compote of fruit or Godey-type ladies. The majority of marked china found in these pieces are American Limoges and are generally marked with the following: "Triumph, American Limoges, Sebring, Ohio, white gold, warranted 22-K, Imperial Victoria-T, Made for Faberware." Or it might be marked with the name of Farber and Shlevin, whoever used it in their aluminum giftware. The trademark of the company making the aluminum border was also on the border. Some of the aluminum-bordered plates and baskets had china pieces with the Indian Tree pattern while others used the gaily painted china from Southern Potteries, the so-called Blue Ridge pottery located at Erwin, Tennessee from around 1920 until 1957. Some researchers have found that the aluminum companies bought seconds from Blue Ridge and attached their aluminum borders. In those days seconds were not all that flawed, and pieces have been seen with minor flaws which certainly verifies the story. None of these pieces have been found so far with any kind of trademark either on the pottery or the border. The same companies made baskets and bowls, mostly baskets, with glass bases. Some of the glass is etched and of good quality while others are not so good. Then there are the pieces with pattern glass insets, some deep, some shallow, and some very attractive.

Plate, aluminum rosettes on handle, berry and leaf design on aluminum border. $40-$60.

Plate with china inset marked Limoges, white gold, warranted 22K, Imperial Victorian-T, Made for Farberware. Mark on aluminum border Wrought Farberware, BKLY, N.Y. 12 inch diameter. Compote of fruit decorates plate. $30-$40.

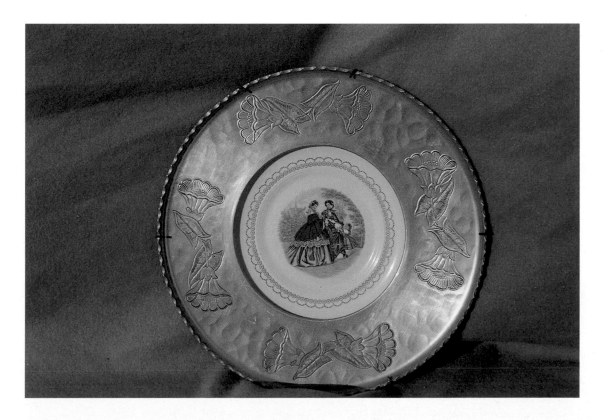

Plate with china inset, identical to one with compote of fruit except this one had two Godey-type ladies. $30-$49.

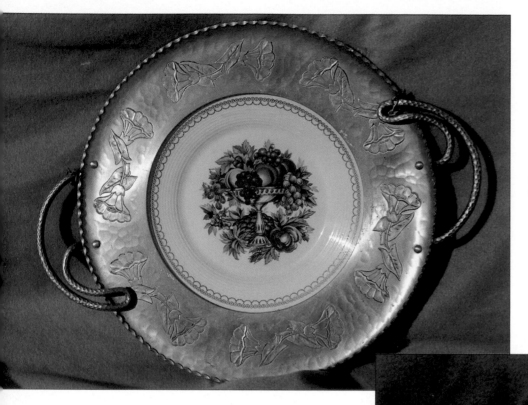

Plate, Farberware trademark, aluminum border. $40-$60.

Bowl with china inset, inexpensive china, curled handle on one side. $18-$35.

Basket with china inset, same marks. $50-$65.

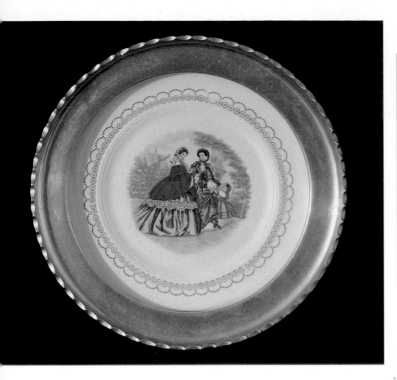

Plate with china inset, 8 inches diameter. Originally had cover to keep food warm, same mark as larger plates. $19-$25 without cover, $25-$38 with cover.

Basket with glass inset, frosted flower design, Farber and Shlevin trademark. $25-$30

Plate, Godey-type ladies in different style dresses, same mark. $30-$47.

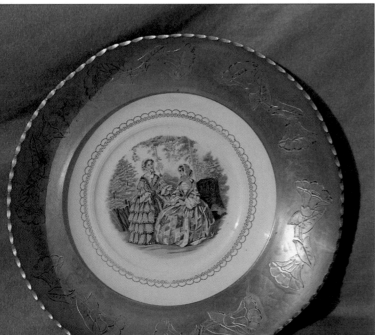

Basket with same design and made by same maker. Pattern glass bowl was substituted for floral decorated one. $24-$29.

Chapter Sixteen:
Condiment Containers

Before and during the heyday of aluminum use, families were large and dining, gracious or otherwise, was done at home. Dining styles differed greatly from family to family, but regardless of style most homemakers were too gracious to put open bottles and jars on the table. They insisted on fancy condiment containers — and the aluminum companies were delighted to oblige. They made containers in every style and shape from the apple-shaped glass containers on aluminum trays to ferris wheels with revolving containers. These pieces are very collectible now and rather expensive due to scarcity, no doubt.

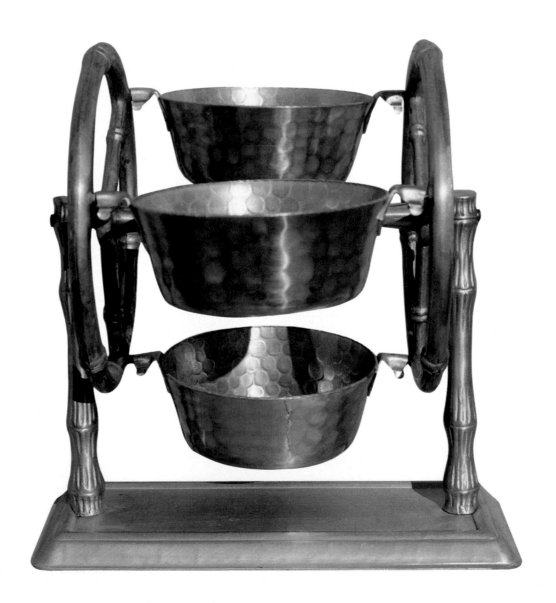

Ferris Wheel style condiment container, Everlast Hand Forged trademark. $50-$75.

Mayonnaise dish, handle on server assures it is Buelinum-made. All Original. $25-$30.

Condiment container or double relish server, Cromwell Hand Wrought Aluminum trademark. $18-$23.

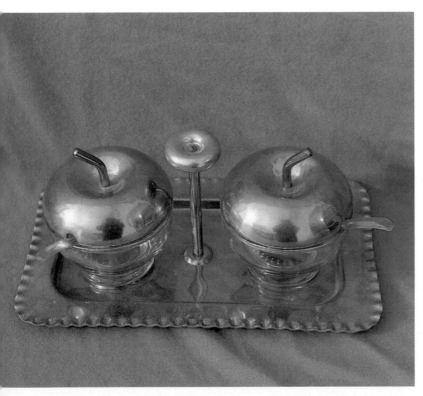

Condiment containers with apple-shaped covers, Cromwell Hand Wrought Aluminum trademark. $24-$29.

Relish server, finial assures Buelinum trademark. $20-$24.

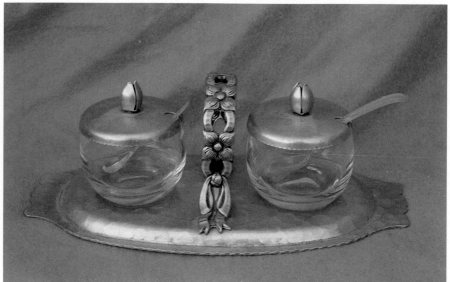

Double relish server, handle indicates Rodney Kent manufacture. $27-$29.

Holder for butter, relishes, and napkins. Unmarked but definitely Rodney Kent. $40-$45.

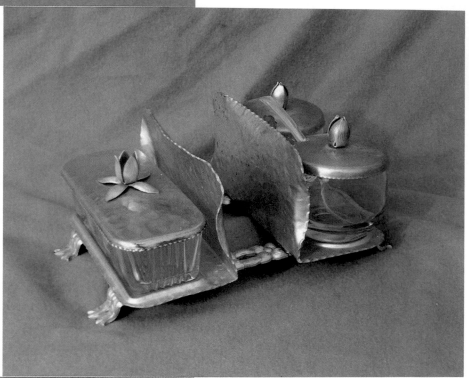

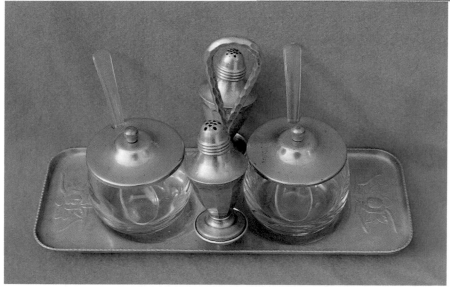

Condiment container, Everlast trademark. $25-$30.

Chapter Seventeen:
Continental's Chrysanthemum
Pattern

The Continental Silver Company appears to have been a subsidiary or perhaps a sales outlet for the Continental Sheffield Silver Company. It was located on Fifth Avenue in New York City which would have been the perfect place for a sales room. This seems to have been another case of a big silver company getting into the very lucrative and popular aluminum giftware business. Whatever the reason, they seem to have made and distributed some of the most beautiful and serviceable pieces. The one thing about their aluminum that would have attracted even the most discriminating hostess was the fact they made complete sets in each pattern. And in those days the one thing most hostesses wanted was sets that matched. For instance, in the chrysanthemum pattern it is still possible today to find a complete assortment of pieces including bread or celery trays, silent butlers, creamers and sugars, crumbers, large and small trays, water pitchers, and an assortment of other serving pieces. Finding an electric percolator and cocktail shaker still requires time. This company used lots of applied leaf designs on various pieces and patterns including the handles of creamers, sugars, candleholders, and salad forks and spoons.

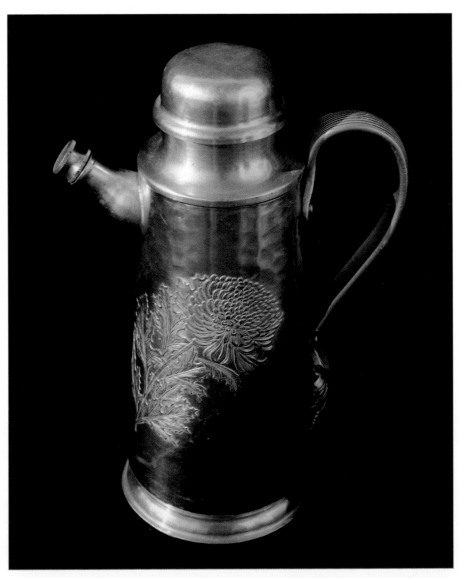

Cocktail shaker, scarce in this pattern. $85-$95.

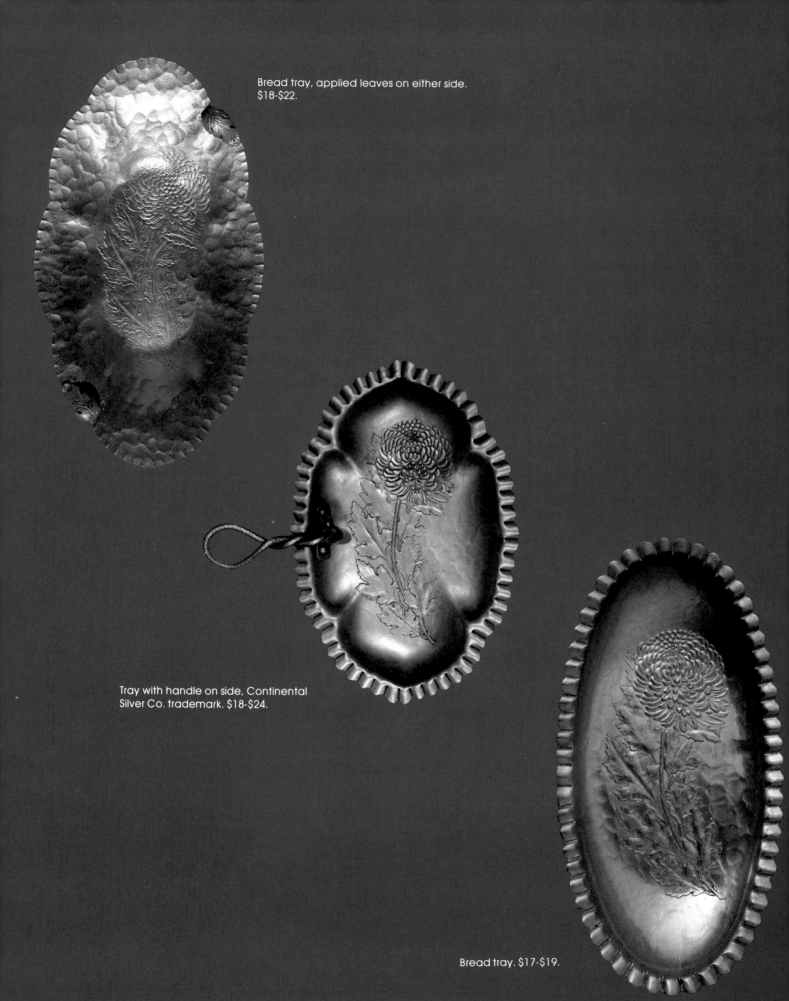

Bread tray, applied leaves on either side.
$18-$22.

Tray with handle on side, Continental
Silver Co. trademark. $18-$24.

Bread tray. $17-$19.

Oblong tray, chrysanthemum design,
Continental trademark. $19-$27.

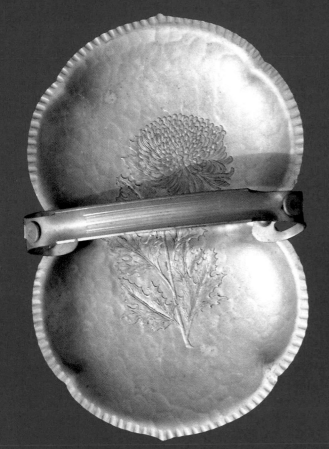

Double tray. $18-$24.

Diamond-shaped tray with handles on
either side. $20-$25.

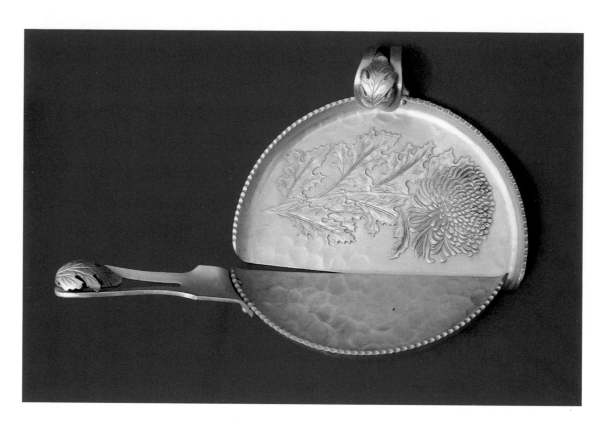

Crumber, applied leaves. $20-$25

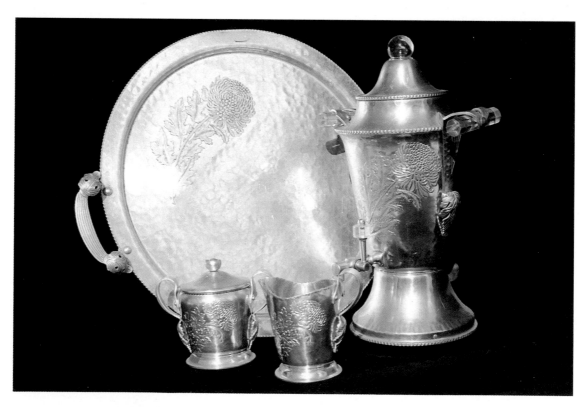

Electric coffee percolator, creamer, sugar dish, and matching tray. All have Continental Silver Co. trademarks. $150-$200.

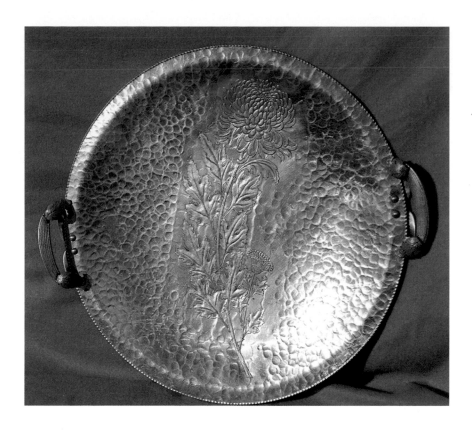

Round tray with applied leaves on handle. $25-$30.

Silent butler, applied copper flower on top, often used with chrysanthemum pattern, Continental Silver Co. trademark. $19-$25.

Chapter Eighteen:
Crumbers

To really understand how many of the aluminum giftware pieces were used and were really needed, one has to go back and study the lifestyles of that period. As we've said before, there was a lot of eating in and a lot of home entertaining, and this in turn meant using large dining room tables, banquet size if necessary. These tables were always covered with large, snowy white, damask tablecloths. The family might eat breakfast and lunch in the kitchen, but dinner was always served in the dining room whether they had guests or not. It was difficult not to drop a few crumbs here and there, but it was absolutely essential the table be cleared perfectly after each meal which meant was not only needed but used daily. The crumber was and still is a two-piece tool that was used to remove the crumbs from the table. One piece was used to do the sweeping and the other to hold the crumbs.

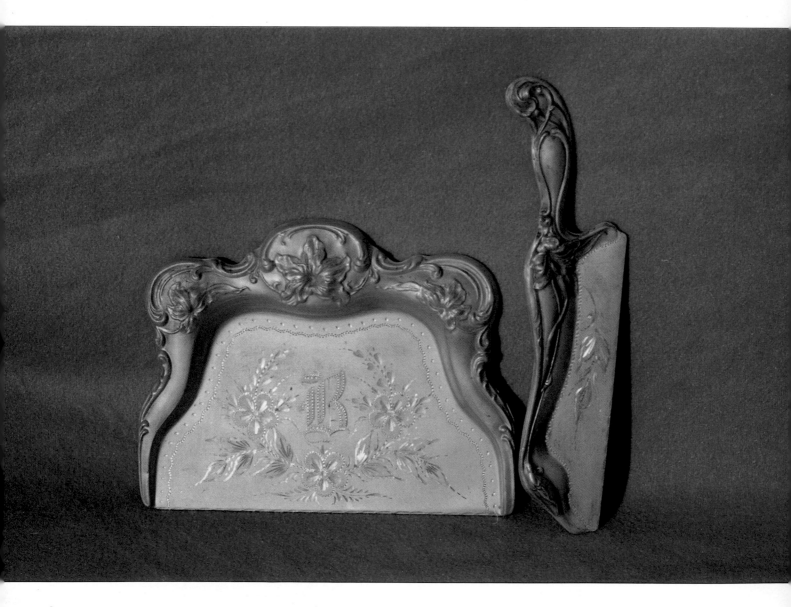

Crumber with monogram, bright cutting, unmarked. $23-$28.

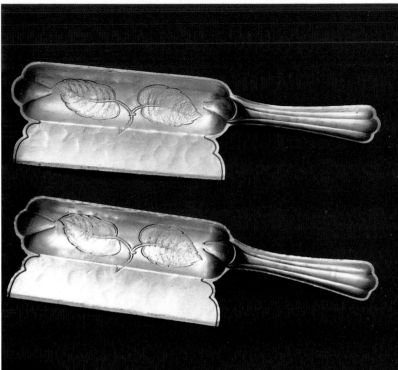

Two single crumbers, matching pieces have not been seen, Farberware trademark. $10-13 each.

Two-piece crumber, grape design, World Hand Forged trademark.
$20-$25.

Two-piece crumber, unmarked. $16-22.

Two-piece crumber, unmarked. $16-21.

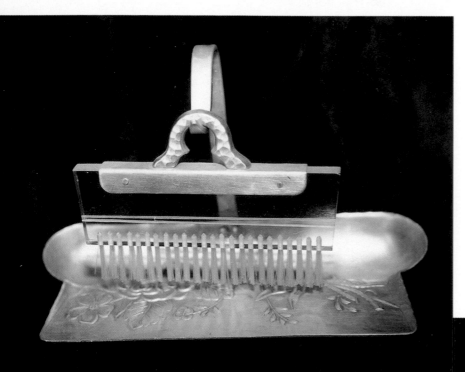

Crumber with hanging brush, Everlast trademark. $23-$28.

Two-piece crumber, Everlast trademark. $25-29.

Crumber with brush, Everlast trademark. $23-28.

Chapter Nineteen:
Desk Accessories

Aluminum desk accessories were never as plentiful as most of the other giftware. Trays for pens and pencils were made as well as blotters of the rocking variety. Then there were complete desk sets consisting of a desk pad, pen and pencil holders, calendars, frames for pictures or family photos, and blotters as many people still used ink pens. The complete sets are extremely scarce today, but parts of them can be found from time to time. There is a possibility one could finally assemble a matching set. There were also advertising pieces like the pencil shown. It was very useful for carpenters as the aluminum holder wouldn't break and it was made to fit a lumber pencil.

Aluminum picture frame, bright cutting, unmarked, scarce. $30-45.

Pen or pencil tray, butterfly design, unmarked. $10-12.

Rocker type blotter, unmarked. $15-18.

Holder for lumber pencil, advertising, pencil goes in one end; eraser in the other. No maker's mark. $10-12.

It is easy to convince yourself and any one else that Everlast was one of the most prolific makers when checking the trademarks on aluminum giftware. They used several different trademarks, but the one that has Everlast as part of it seems to dominate the field. One trademark has the letters E.M.P.C. for Everlast Metal Products Company which could have been the original Everlast company or a subsidiary. With business as brisk as it seems to have been it would not have been unusual to have had several branches. They made everything from coasters to serving carts, and the designs ranged from bamboo to floral, from berries to horses. Some of the pieces are plain while others have designs that are very busy such as sailing ships, birds, and Mexican siesta scenes. If one wanted variety but only wanted to collect the works of one company, Everlast could fill the bill.

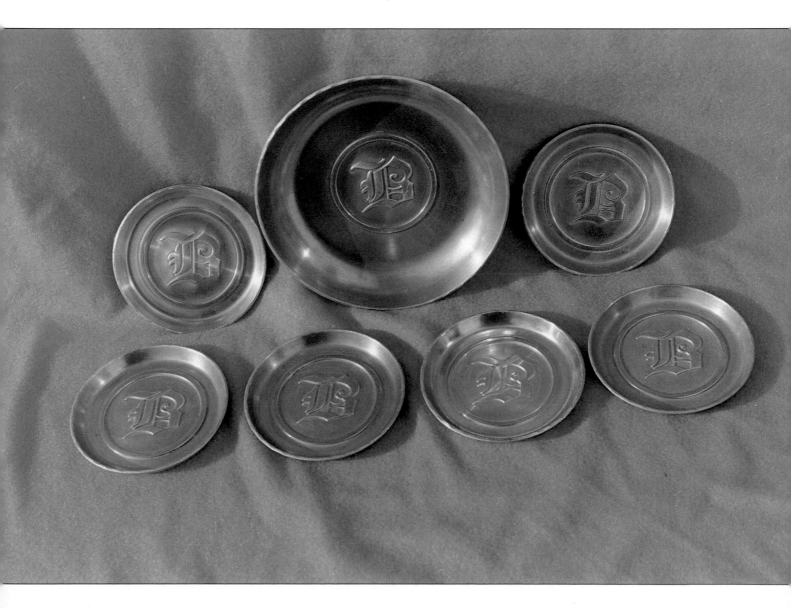

Six monogrammed coasters with a larger one that could have been used as an ashtray. $27-$35.

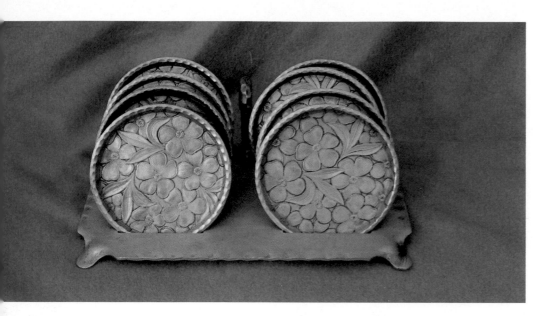

Eight coasters in caddy. Good aluminum and workmanship. $22-27.

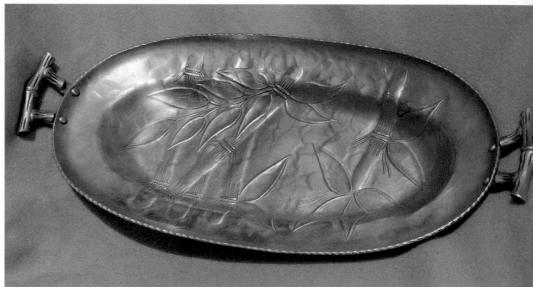

Bread tray, bamboo pattern. $20-$24.

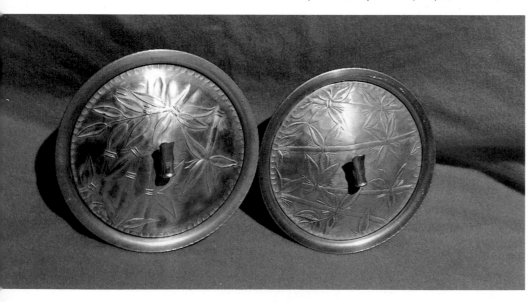

Casseroles in two sizes, bamboo pattern, $18-$25 each.

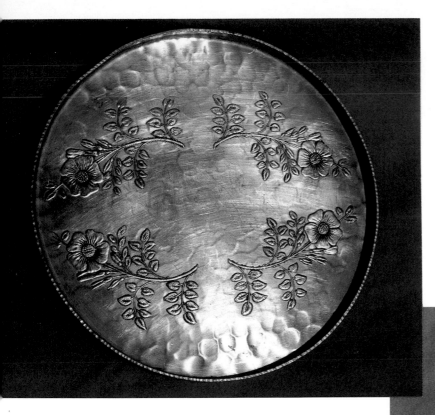

Round plate. $24-$29.

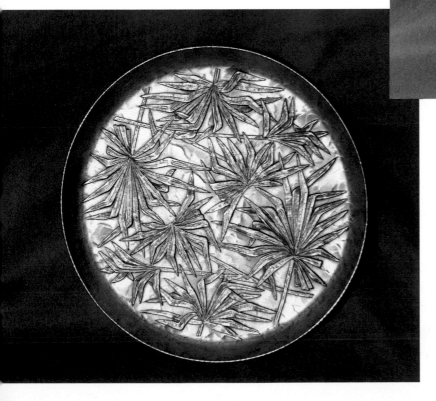

Tray in ivy pattern, originally had glass dish in center. $18-$20.

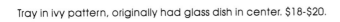

Round plate or tray in palm pattern. $19-$25.

Chapter Twenty-One:
Eye Glass Cases

The patent date of 1909 on two of the illustrated open and close type cases furnish us with thoughts worth pondering when trying to pin down a reasonable date that aluminum first began to be used for making personal items. We know that around 1850 an aluminum baby rattle was made for the son of Napoleon III. This was probably done more as a status symbol than anything else as aluminum was more expensive than gold at that time. As it became less expensive it still wasn't used as freely as one would have thought. Now the other eye glass case, the chatelaine type that appears to have been made expressly for Benjamin Franklin type glasses, defies dating. Judging only by wear and tear it doesn't seem too old, but then it could have been packed away for years. Unlike the other two, this case isn't made entirely of aluminum, but is only decorated with filigreed aluminum. The actual case is made of leather. This case could have been made later for a special person, or it could have been made for some of the older people, my great-grandmother among them, who continued to use their old glasses and their chatelaines well into the 1920s. Eye glass cases are not that plentiful today, but by the same token there aren't many people collecting them.

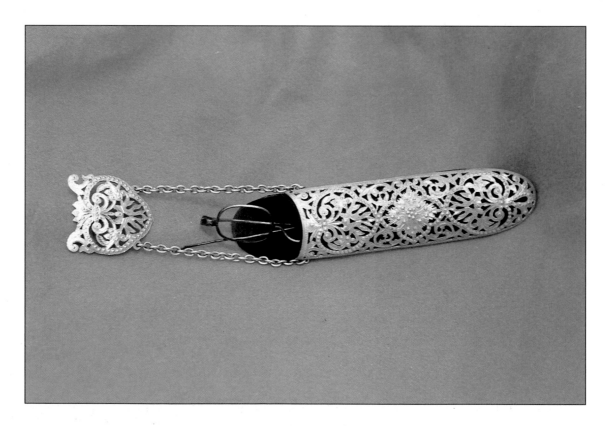

Chatelaine-type case for eye glasses. Leather case with filigreed aluminum decoration, unmarked. $85-$95.

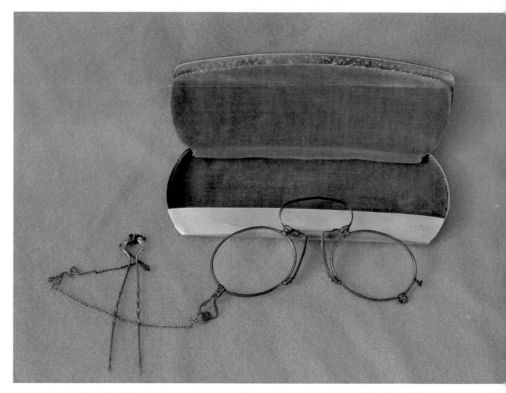

Aluminum eye glass case with pair pince-nez glasses and attached gold plated chain and hairpin. Hairpin served dual role — it helped hold the glasses in place, and it was used to pick knots out of tatting, when needed. Trademark is letter A in double circle and Pat. Feb 9, 09. Complete $45-$50.

Aluminum eye glass case same as above, same markings. $15-$18.

Aluminum eye glass case with vertical stripes, unmarked. $12-$15.

Chapter Twenty-Two:
Floral Designs

It would be next to impossible to find pieces made by any of the aluminum giftware companies that didn't have among their offerings some floral designs. They were trying to please the customers as we have always loved flowers and floral designs. The patterns range from the exquisite iris to the realistic roses. Of course there are also the beautiful chrysanthemums made by both the Continental Silver Company and the Forman Family. It would be difficult to say whether floral designs were more plentiful than fruit, but it does appear to be a close race. At least these patterns are plentiful and not too expensive yet.

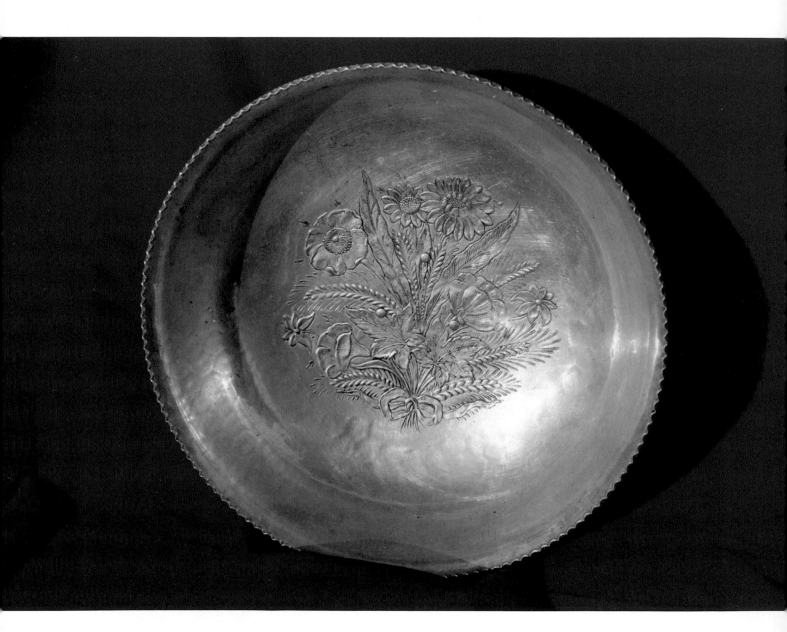

Bowl, floral decoration, unmarked. $20-$25.

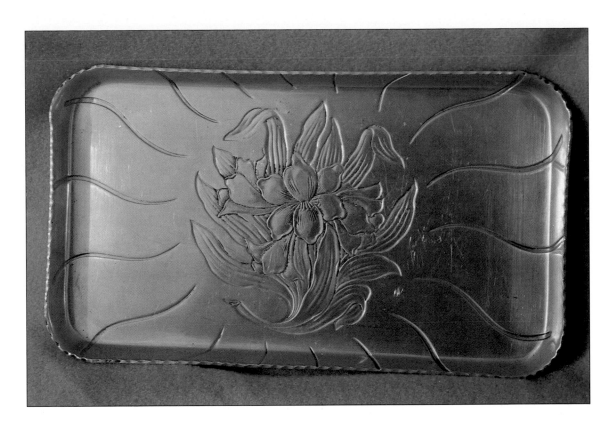

Small tray with single flower, unmarked. $10-$13.

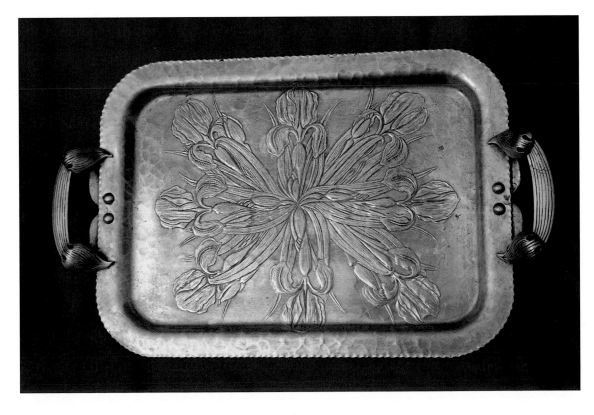

Tray, iris decoration, Pat. 7-30-46, Continental Silver Co. trademark. $38-$47.

Tray, unmarked. $12-$17.

Tray, border of leaves and flowers, Everlast trademark. $20-$25.

Tray, 14 by 19.5 inches, rose design, Keystoneware Aluminum trademark. $40-$50.

Low bowl, Forman Family trademark. $18-$23.

Handled tray, mixed floral design, Hammercraft Hand Hammered trademark. $15-$18.

Pattern glass candy dish with aluminum cover, unmarked. $12-$15.

Chapter Twenty-Three:
Fruit Designs

One of the most beautiful pieces in this category is decorated not only with fruit but also an assortment of flowers. It is truly elegant right down to the butterflies hovering over the flowers. There is no indication of the company that made it other than the mark "Hand Finished Aluminum" which could be one specific company or the term could have been used by several companies working together. Grapes were used frequently, alone or in a design with other fruits. Often a few vegetables would be included. This is another design where pieces are plentiful and not yet too expensive.

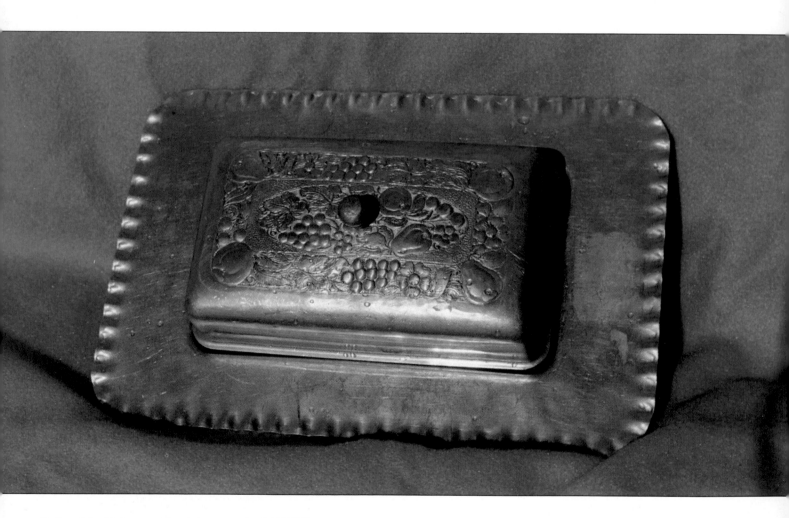

Butter dish with large underplate, unmarked. $25-$30.

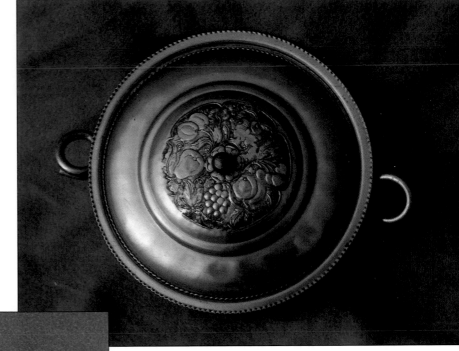

Small covered dish, Cromwell Hand Wrought Aluminum trademark. $18-$23.

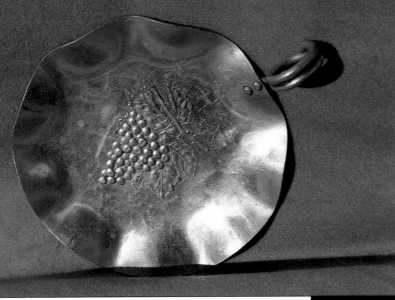

Small serving dish with handle, Hammercraft Hand Hammered trademark. $14-$17.

Basket, Cromwell Hand Wrought Aluminum trademark. $18-$24.

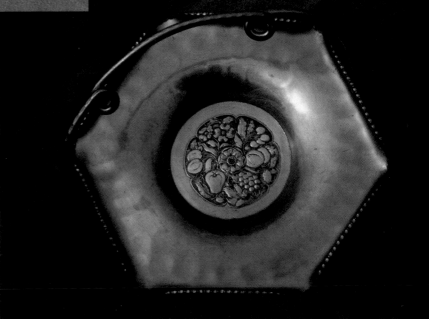

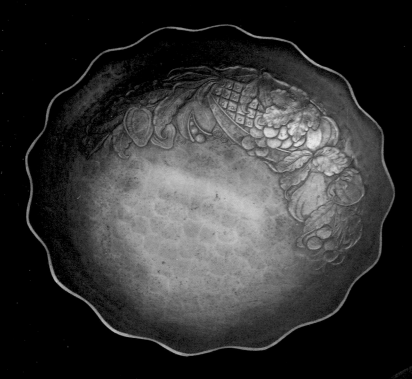

Large bowl, 12 inches diameter, 3 inches deep, Lehman Aluminum Hand Forged trademark. $25-$30.

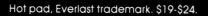

Hot pad, Everlast trademark. $19-$24.

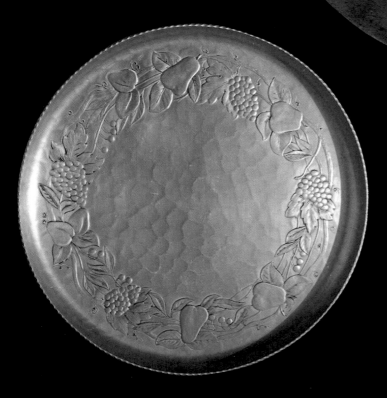

Round plate with fruit design, Everlast trademark. $15-$18.

Chapter Twenty-Four:
Hobbyist

One of the reasons for the abundance of all kinds of aluminum giftware today is the fact that for several decades both the forges and the hobbyists seemed to have been competing with each other. The hobbyists were busy because they couldn't afford the more expensive forge-made pieces and the forges were busy making pieces for people who weren't talented enough to make their own. Another reason for the hobbyists to work so hard was the fact they had been involved in crafts of some kind most of their lives, and they apparently couldn't stop making things with their hands. They might not be able to afford it, but they also liked to give gifts to their friends and family. Whatever the reason, both groups kept producing aluminum giftware. Sometimes it was a gift for a special occasion; other times it was just something they wanted someone to have. It wasn't necessary to date the pieces made by the hobbyists, but often they etched in the date and the occasion like the one given for a Christmas present in 1938. As we have said before some of these pieces were well done, while some were a waste of good aluminum.

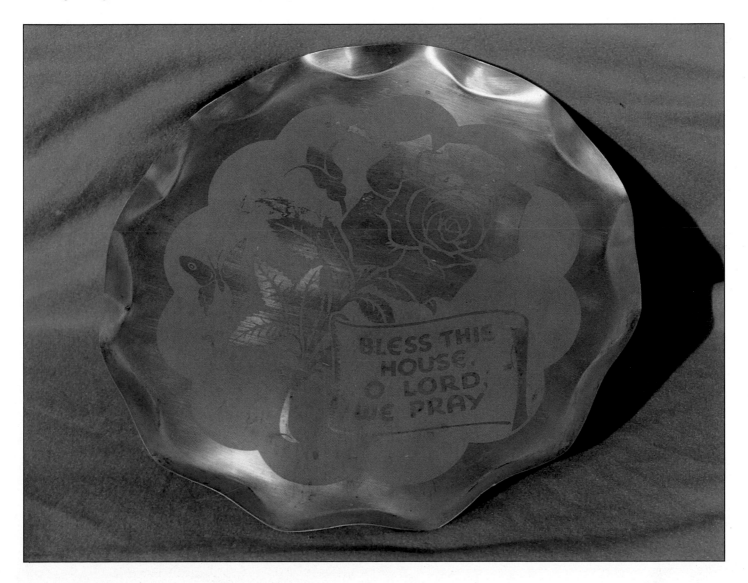

Tray with "Bless This House, O Lord, We Pray." Stamped on back with rubber stamp "Christian Witness Decor-a-tray." $12-$15.

Plate, unmarked. $20-$25.

Tray, heavy, etched on back "Nellie from Mildred, Christmas, 1938." $12-$15.

Tray, 5.5 by 8.5 inches, marked Hand Made Tait. $9-$12.

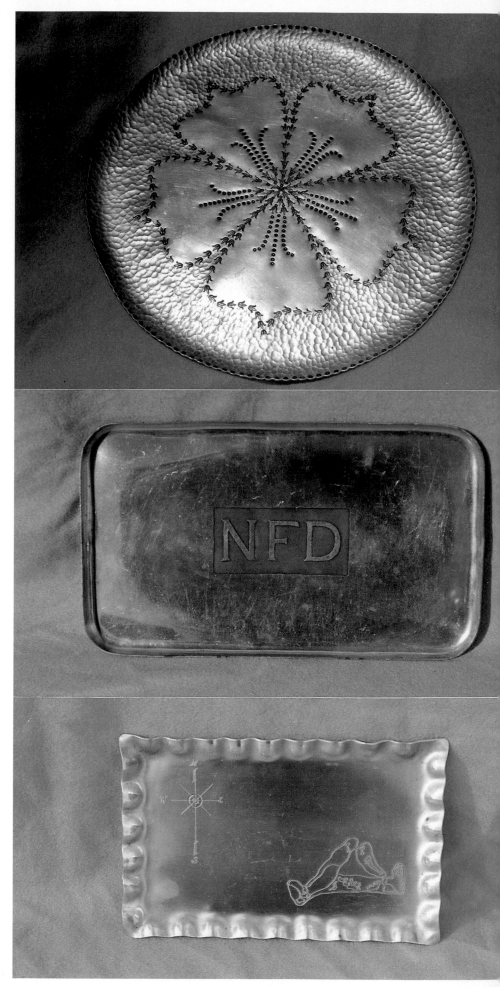

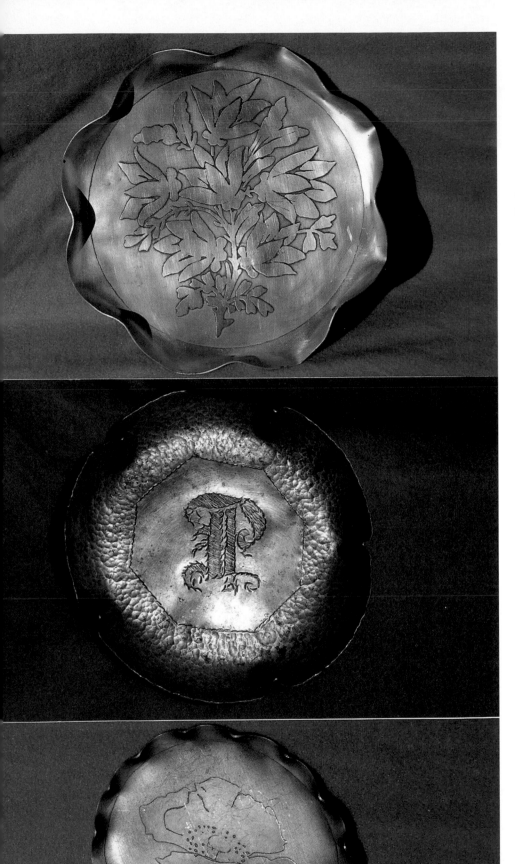

Tray, good workmanship, unmarked. $10-$12.

Plate, monogrammed, unmarked. $10-$13.

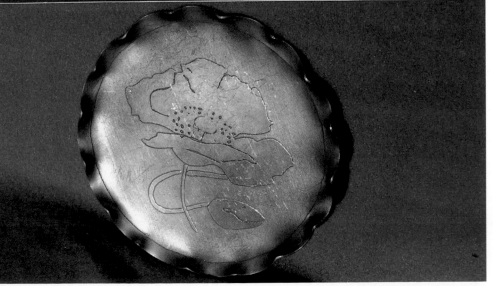

Small tray, unmarked. $7-$9.

Chapter Twenty-Five:
Ice Buckets

Early on, people didn't have ice makers in their refrigerators, in fact until around 1930 electric refrigerators weren't all that plentiful because electricity wasn't available except in the larger towns and cities. In the rural areas people used iceboxes that were supplied by an iceman who came around every couple of days or so, and put a block (usually about 50 pounds) of ice in the box. Much earlier, Maine ship captains had taken native ice which had been cut in the winter and stored until needed to islands in the south where it was traded for rum — to bring back home. The ice was packed in sawdust for the trip south. After World War II the majority of people began using ice in all their beverages so the ice bucket became a necessity on the dining table as well as the bar. Only the very affluent could afford silver ice buckets, but with the advent of aluminum, everybody could afford an aluminum one.

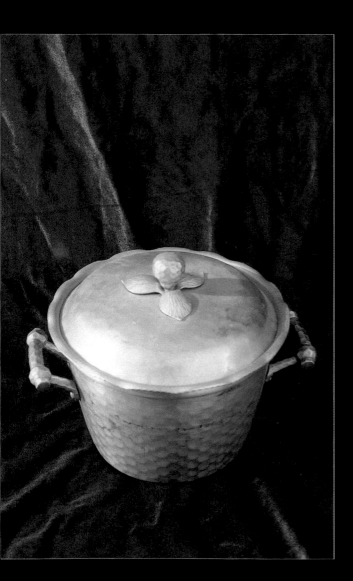

Ice bucket, trademark Everlast Cooler with polar bear and glacier, heavy. $23-$27.

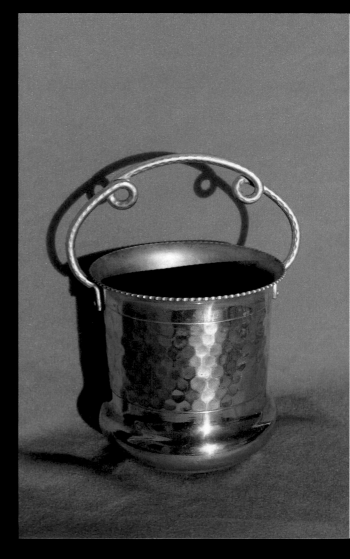

Open ice bucket, Cromwell Hand Wrought Aluminum trademark. $15-$20.

Some aluminum jewelry was made to be sold as souvenirs while other pieces were made by the hobbyists. Then there are some pieces that are so ugly and poorly made, one wonders why they were ever made at all. Apparently they are all collectible as some people have been seen who only collect aluminum jewelry. One of the most unusual pieces of jewelry seems to be an aluminum bracelet with holes somewhat like the perforated paper used in needlework. The holes in the only one we have seen is filled with variegated thread in a design that more or less resembles needlepoint. About as many c-shape or cuff bracelets have been seen as the link style. Many of the aluminum or aluminum decorated belts will have the appearance of Indian workmanship or design except one that was probably made to attract the motorcycle trade. It is leather with aluminum decorations and was "Handmade in Morocco" according to the label.

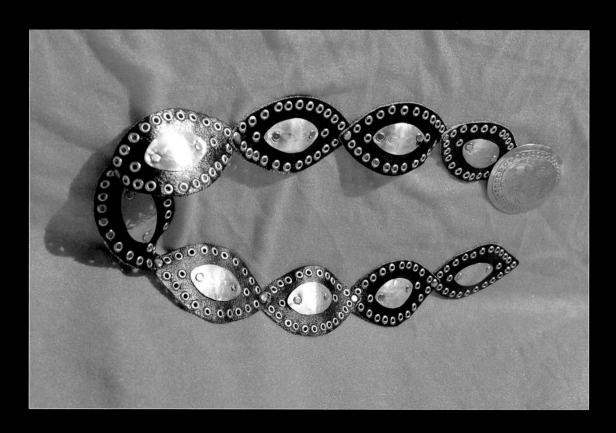

Leather belt decorated with aluminum, marked Made in Morocco.
$25-$30.

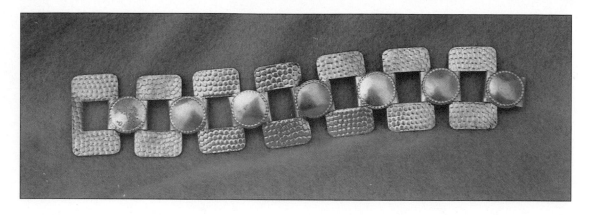

Bracelet, light weight, inexpensive. $5-$7.

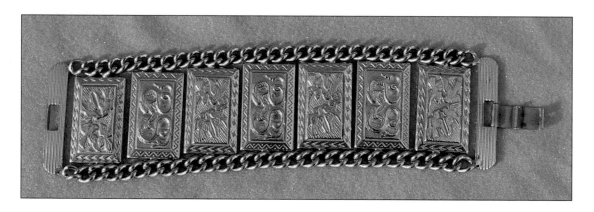

Link bracelet, links are aluminum, balance is not. $10-$13.

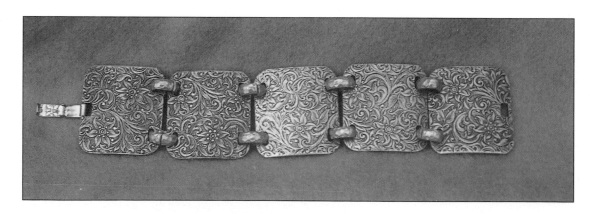

Link bracelet, good quality, unmarked. $25-$30.

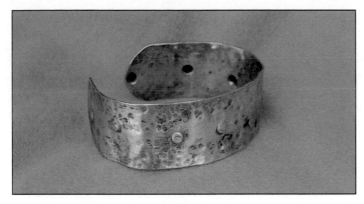

Hobbyist-type bracelet. Probably made by serviceman during World War II out of scrap aluminum. $9-$15.

Cuff bracelet, tapering ends in back, unmarked. $13-$15.

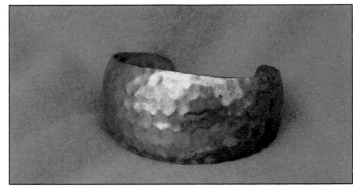

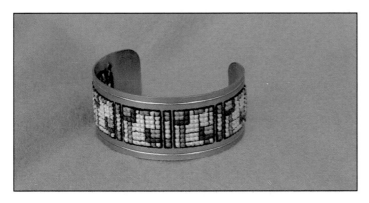

Aluminum c-shaped or cuff bracelet made like perforated paper used in needlework. Open work has been filled in with variegated thread. Unmarked. $18-$25.

Cuff bracelet, could be hobbyist-made, unmarked, $13-$17.

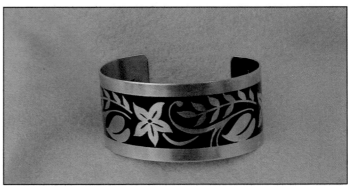

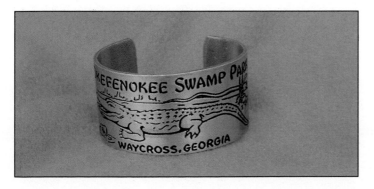

Souvenir cuff bracelet, Okefenokee Swamp Park, Waycross, Georgia, unmarked. $13-$18.

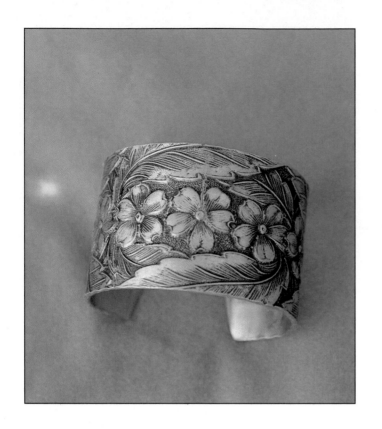

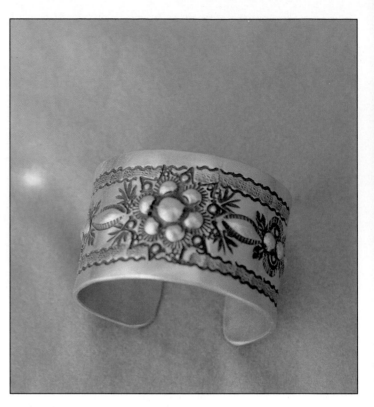

Apple blossom cuff bracelet, excellent quality, unmarked. $20-25.

Cuff bracelet, good quality, unmarked. $22-27.

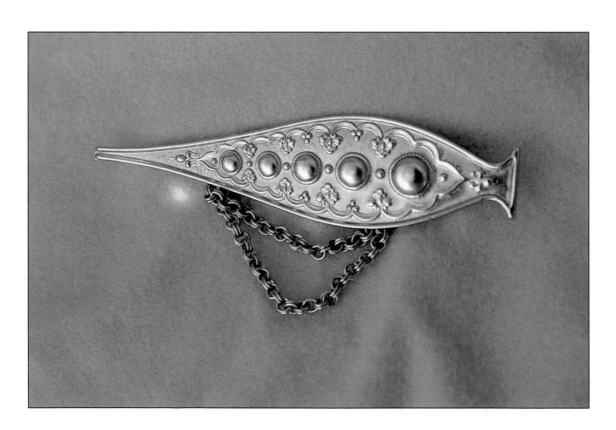

Pin with double chain, unmarked. $10-12.

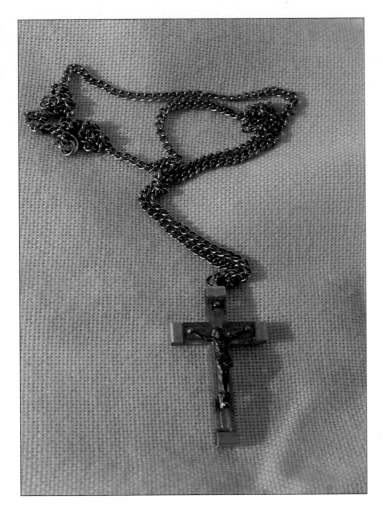

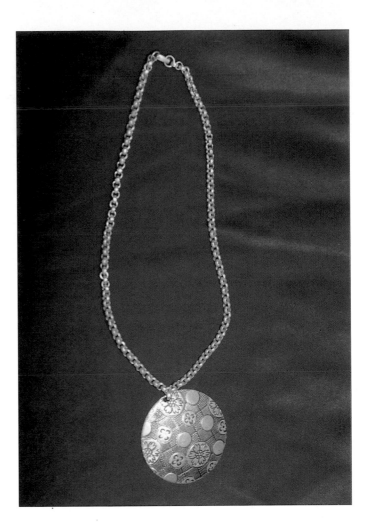

Necklace with cross, All aluminum except blue plastic, marked
Lourdes, France. $20-$25.

Aluminum necklace, unmarked. $10-12.

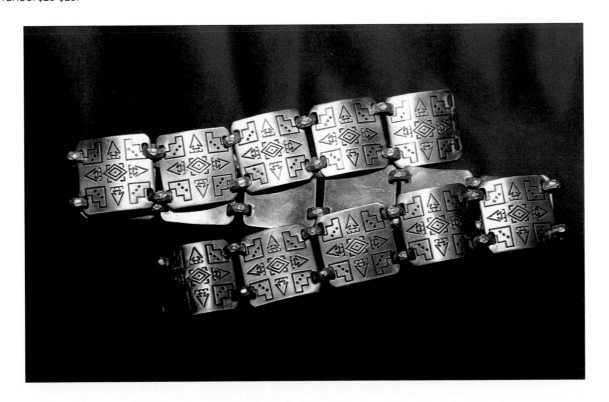

Aluminum belt with Indian motif, unmarked. $25-$30.

Chapter Twenty-Seven:
Kensington Ware

Collectors seem to form an opinion about Kensington aluminum quickly — they either like it very much or they dislike it. There doesn't seem to be any middle-of-the-road attitudes about this one. Those who like the modernistic style prefer it over the hammered pieces while those who want the ornately decorated pieces steer around the plainer Kensington. The Kensington pieces are rather stark as the designs will usually be a very weak etched design or maybe a little applied copper decoration. The first information on this ware was found in the 1934-35 Ovington's winter catalog. This alone would have been enough to recommend it as Ovington's was an exclusive Fifth Avenue gift shop in New York at the time. They described it as a new metal that was untarnishable with the soft lustre of old silver. This ware was made by a branch of the Aluminum Company of America (ALCOA) located at New Kensington, Pennsylvania, hence the name. Despite the fact they advertised it as untarnishable, it would show marks and scratches. Perhaps in the early days it was taken better care of and didn't have the marks that have been seen later. Some of the pieces today will have lots of marks that appear to have been made by a sharp knife used to cut something on the piece, maybe cheese. After the war when the aluminum had lost a lot of its popularity, many pieces were relegated to furnished apartments where the renters couldn't have cared less about it. The trademark used on these pieces is the letter K with a deer's head above and the word Kensington underneath.

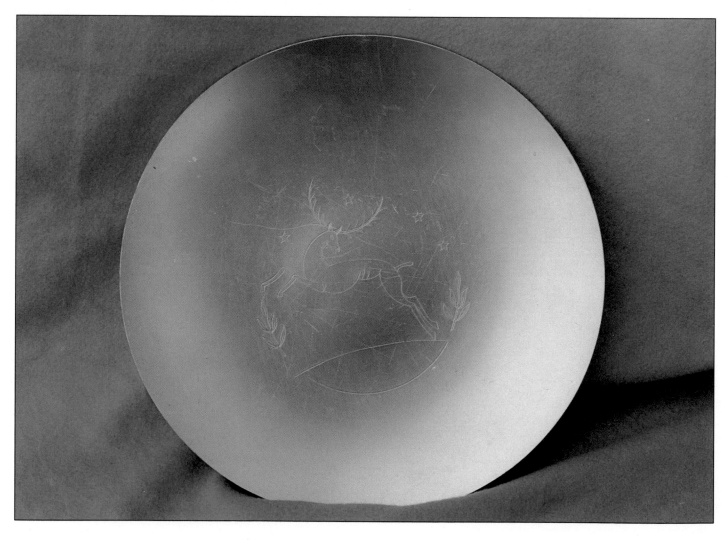

Plate, 15 inches diameter, leaping deer design, Kensington trademark. $22-$26.

Covered vegetable dish. $22-$28.

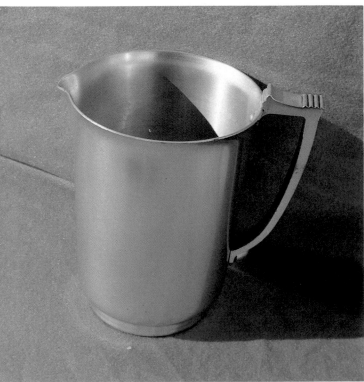

Bread tray, Kensington trademark. $12-$15.

Covered vegetable dish open.

Beverage pitcher, Kensington trademark. $40-$45.

Three coasters. Kensington trademark is letter K with a deer's head above and the word Kensington underneath. $10-$12 each.

Plate, 12 inches diameter, Kensington trademark. $18-$24.

Shell-shaped dish. $18-23.

Large plate, 17 inches diameter, unmarked but has all the qualities of Kensington. $18-25.

Chapter Twenty-Eight:
Lazy Susans

Judging by the number of Lazy Susans available today it would be difficult to argue that they weren't one of the most popular of all the aluminum giftware. They were large enough to show off the design to an advantage, and the large one would accommodate the largest party. It is also believed that one was made in nearly every pattern which allowed the hostess to have a complete set of serving pieces. On the down side they are hard to display as they require so much space. Several years ago I decided to have space built to display some of my aluminum that had been packed away for years. I thought I might have accumulated as many as half a dozen lazy Susans through the years. Imagine my chagrin when I unpacked a total of twenty-six when I had space for six to eight. If you aren't looking at them you forget how large they can be as they usually average from 12 to 18 inches in diameter and are 4 to 5 inches tall. But they are beautiful and extremely useful for any hostess. In fact, they are being used more and more by catering companies these days. Many of the large aluminum pieces are as they gleam like old silver, if polished, and they are unbreakable.

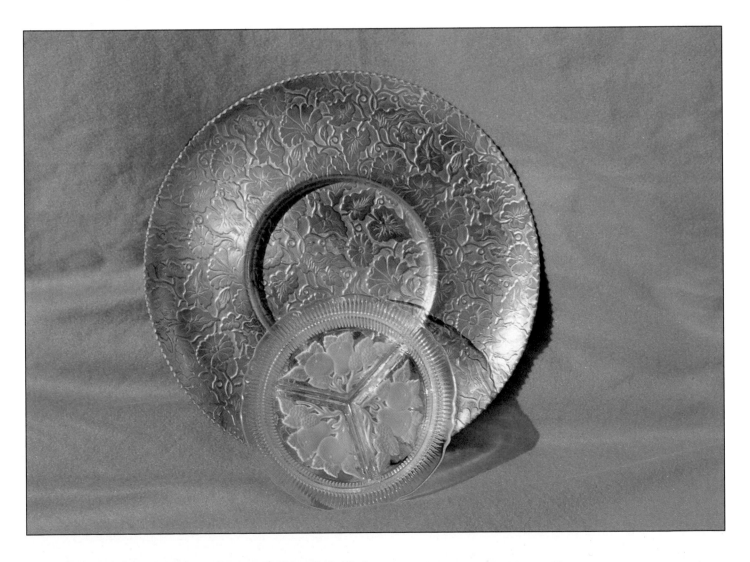

Small Lazy Susan, 14 inches diameter, 2.5 inches tall. Trademark is the letters LA in a bell with Silver Co, Inc. underneath. $27-$34.

Lazy Susan, 18 inches diameter, 4 inches tall, Continental Silver Co. trademark. $35-$45.

Lazy Susan, fruit and berry design, Everlast trademark. $30-$35.

Top of Wild Rose Lazy Susan, Continental Silver Co, trademark. $35-$40.

Lazy Susan, all over floral design. $20-$27.

Chapter Twenty-Nine:
Marriage Pieces

The term marriage is one we all use in antiquedom to describe two pieces of furniture that have been put together to make one. The pieces have to be quite similar, so similar, in fact, that the person putting them together hopes they will fool a buyer. I think we can use the same term when two pieces of aluminum, sometimes one less desirable than the other, are put together. Since this custom seems to be edging into the mainstream more and more, it means we are all going to have to be more careful. We are going to have to inspect pieces more closely before we buy them. We can't take anything for granted. The first marriage piece I saw was a chafing dish with a Rodney Kent base and a Buenilum top. The casserole used as the top was so plain it fit beautifully, but the difference was noticeable. As proof that marriage pieces are getting better, the next piece I saw was the illustrated chafing dish. It also has a Rodney Kent base and the cover from

what is believed to be a Rodney Kent casserole. But there the similarities end. The casserole used on this one is from a very cheap piece, one probably made in Italy. It is thin aluminum and very light. Another baffling piece is the tidbit tray. Whether or not it is a marriage piece has not yet been decided. It is strange. There can be little doubt but what the top and bottom have been put together as they have entirely different designs, but the part that defies identification are the small cups or trays attached to the bottom. They seem to have been attached professionally, yet they seem to have little in common with the rest of the piece. It is possible that some man experimenting with aluminum made the piece — to fit his wife's requirements. The latest marriage pieces we have seen are votive candle holders in aluminum candle holders. They are attractive and quite useful as long as the buyer knows what he or she is getting — and pays accordingly.

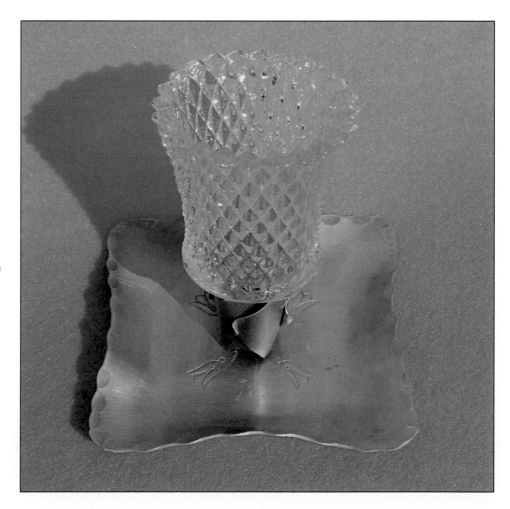

Saucer candleholder with new, glass votive candle holder. Not original. $8-$10 single.

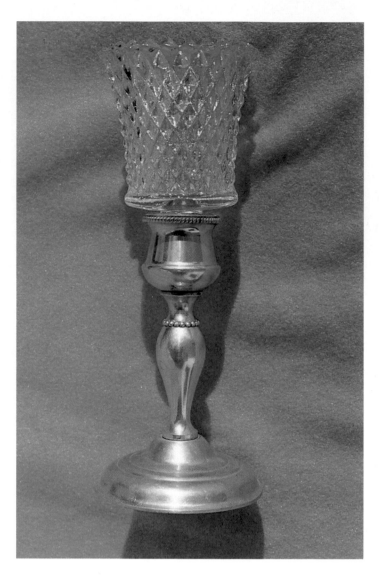

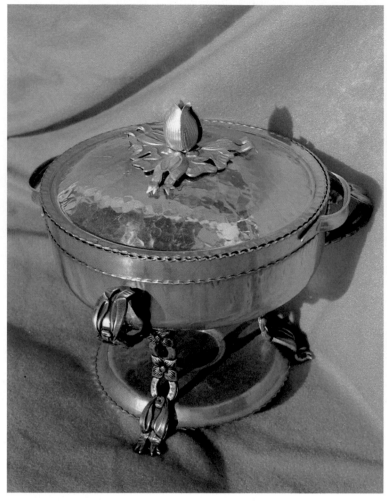

Chafing dish with Rodney Kent stand and possibly cover, but pan is thinner and cheaper aluminum, unmarked. $10-$15 as is.

Tall candleholder with new glass holder. $10-$12.

Tidbit tray, bottom and top do not match. Small coaster type pieces on bottom seem to be professionally attached, yet they match nothing else, unmarked. $8-$10.

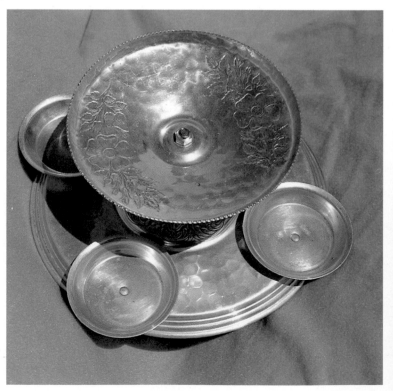

Chapter Thirty:
Milady's Boudoir

In the 1940s some of the customs were not that far removed from those practiced by milady's grandmother. Many ladies still visited old friends nearly every afternoon. Unless they stayed home to receive callers, they went calling. As it had been in the past, calling cards were a very important part of this ritual because these cards had to be readily available to leave at any residence when the lady of the house was not at home. And in those days they didn't just drop the cards into a pocket or purse, they were kept in calling card cases that might be made of mother-of-pearl, silver, silver plate, or aluminum. The illustrated, aluminum card case has the full name of the original owner engraved on the front. She said her husband bought it for her at a fair (or carnival) in New Brunswick, Canada, in the 1950s. She strongly believed the majority of small pieces such as toothpick holders, salt and pepper shakers -- especially the engraved and monogrammed ones, picture frames, and napkin rings came from fairs or carnivals held around the country at that time. These fairs and carnivals are still being held in both Canada and America in the fall, but as far as is known there are no aluminum pieces available, with or without bright cutting and engraving. Bright cutting was a form of engraving, the kind show and fair people could do easily, and something that would make the item more desirable. Souvenir pieces of all types were very popular at that time. Then there were the dresser sets consisting of hand mirrors, brushes, combs, and assorted items that were favorites for young men to give to the girls of their choice. Many were made of aluminum and had bright cutting. Pin trays for her dresser was another favorite, especially the aluminum ones that didn't break like glass.

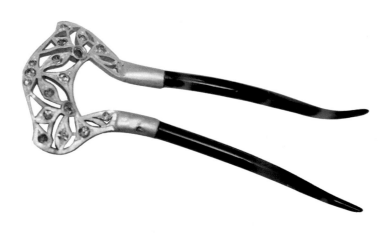

Comb for milady's hair. Aluminum top with glass stones. $15-$20.

Pin tray, center has Boston, Mass. in bright cutting, bird etched and painted. $12-$15.

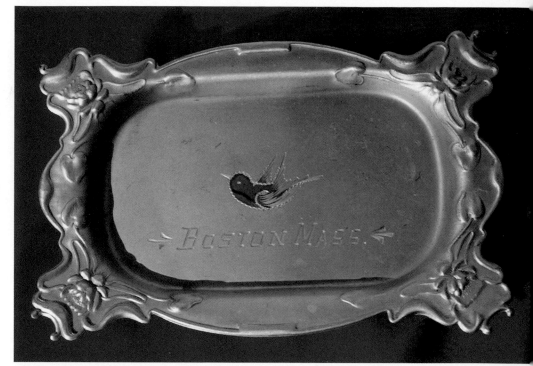

Card case, aluminum, bright cutting, owner's name etched on top, probably from a fair. $15-$20.

Pin tray with "Needles and Pins! Needles and Pins! When a Man's Married His Trouble Begins" painted in the center. $7-$9 as is, $12-$15 good condition.

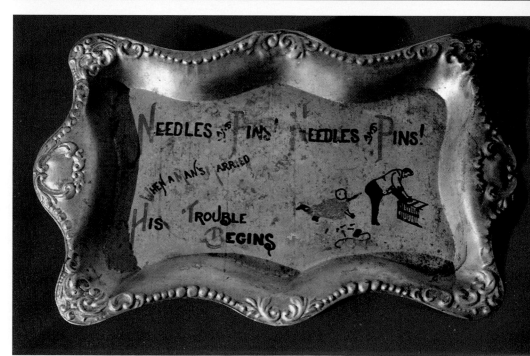

Hand mirror, aluminum, bright cutting, unmarked. $25-$35.

Clothes brush, bright cutting. $8-$12.

Stamp box open, showing monogram.

Blotter dainty enough for milady's desk, bright cutting, un-marked. $12-$15.

Aluminum stamp box, bright cutting, monogrammed. $15-$19.

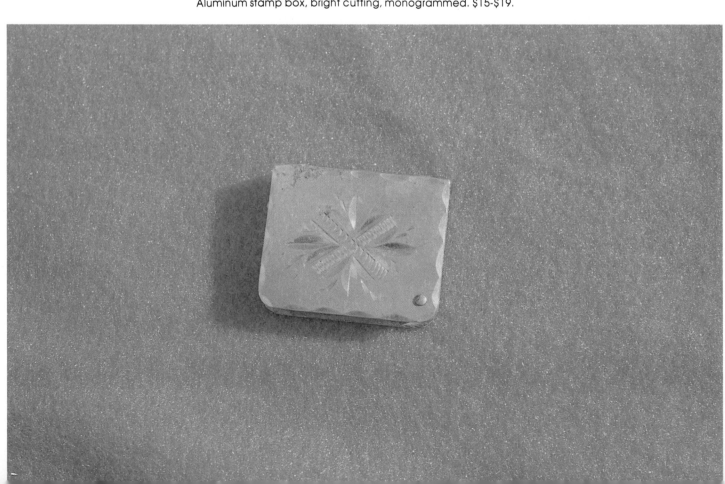

Chapter Thirty-One:
Napkin Rings

Another phase of gracious living left over from the Victorians was the use of napkins, real fabric napkins preferably snowy white damask in 24 by 24 inch sizes. Hand hemmed ones were even more desirable. It was permissible to fold them and leave them on the left side of the plate, but a napkin ring was considered more correct. The napkin ring might be cut glass, sterling, or in later years it was more likely to be made of aluminum. Some of the aluminum ones are quite plain while others are decorated with bright cutting indicating they could have been bought at a fair, or they could have been prizes in some of the games. Paper napkins are a later bloomer which coincided with the introduction of the paper napkin holders.

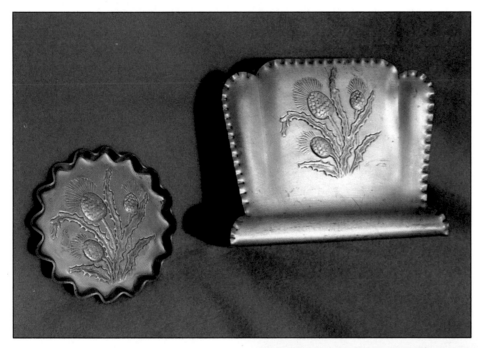

Napkin holder and coaster, thistle pattern, unmarked. $17-$24 for set of 6 coasters, $12-$15 napkin holder.

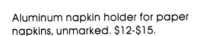

Aluminum napkin holder for paper napkins, unmarked. $12-$15.

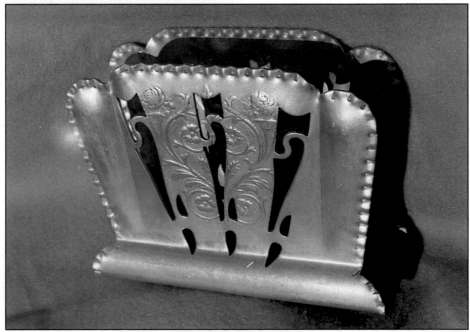

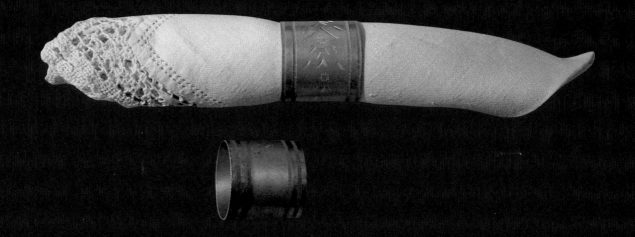

Aluminum napkin rings, unmarked. $16-$20 for 6.

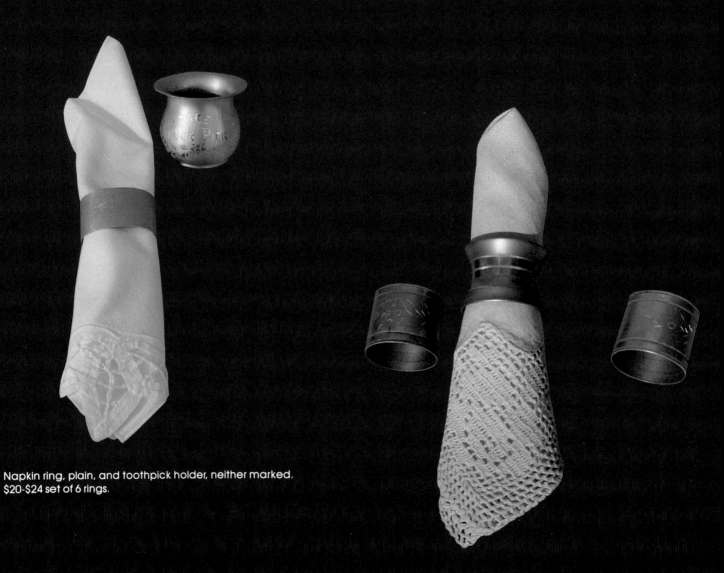

Napkin ring, plain, and toothpick holder, neither marked.
$20-$24 set of 6 rings.

Napkin rings in three styles, unmarked. $18-$22 set of six.

Chapter Thirty-Two:
Novelties

Many pieces originally made as novelties have been absorbed into other categories through the years. Perhaps the cigar holders shown in Chapter Forty-Three, *Smoking Accessories*, were a novelty when first introduced, as men at that time preferred leather cases in which to carry their cigars. It has been said that the single aluminum cigar case or holder was given out free in the Thirties and Forties with the purchase of a certain kind of expensive cigar. So many of the things that were considered novelties at the time are no longer thought of that way. One novelty which remains the same is a large aluminum thimble that ended up as a pin cushion. Written around the sides is the old adage, "A stitch in time saves nine." Then there are numerous advertising items from that period such as the heart-shaped book mark from New Hampshire. No one has offered a solution for using the handled urn piece except the wit who thought it would make a great cremation urn.

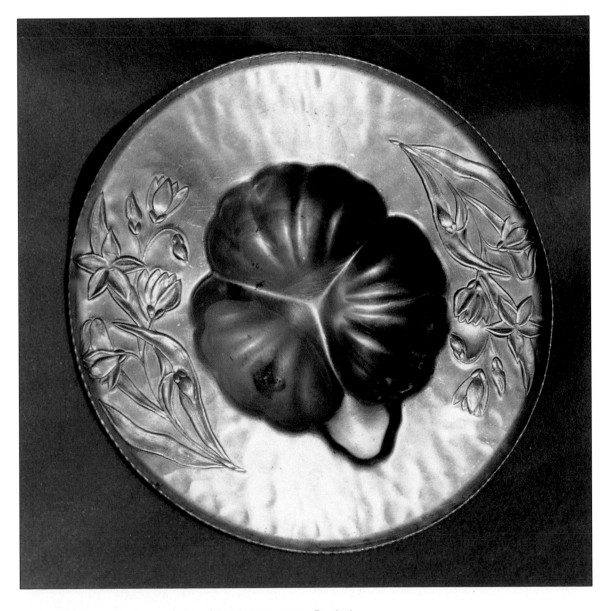

Plate originally had a very odd-shaped dish in the center, Everlast trademark. With original dish $35-$40, without $20-$25.

Bookmark, advertising, unmarked. $8-$10.

Urn, possibly for flowers, unmarked. $18-$23.

Large aluminum thimble with pin cushion, unmarked. $11-$15.

Chapter Thirty-Three:
Nut Bowls

It hasn't always been possible to buy nuts that were shelled and packed in tins. There was a time when people kept nut bowls filled with whatever nuts were available, either in the kitchen or in the room where the family gathered at night. Wooden bowls had long been a favorite until aluminum ones became available. There are still nut lovers who keep a bowl, preferably an aluminum one, full of nuts close by to enjoy on a long winter's evening. But they aren't as popular as they once were, which in turn makes the demand lighter.

Nut dish complete, unmarked. $20-$24.

Nut dish complete, unmarked. $23-$27.

Nut dish complete with tools, unmarked. $25-$30.

Chapter Thirty-Four:
Pine Cone Designs

One of the reasons pine cones are so well known is the fact that there isn't a section of the country that doesn't have pine trees of one kind or another, and all of those trees have some kind of cones. Apparently these were patterned after many varieties of cones as only one or two appear to be like the old southern pines that have such large cones. They are all attractive and have beautifully detailed pine needles.

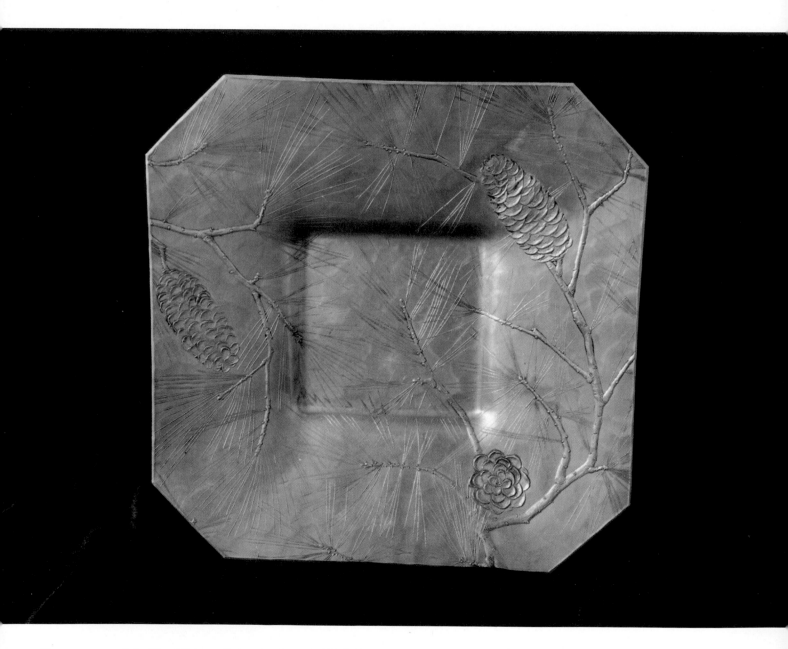

Heavy square plate, Wendell August Forge trademark. $50-$65.

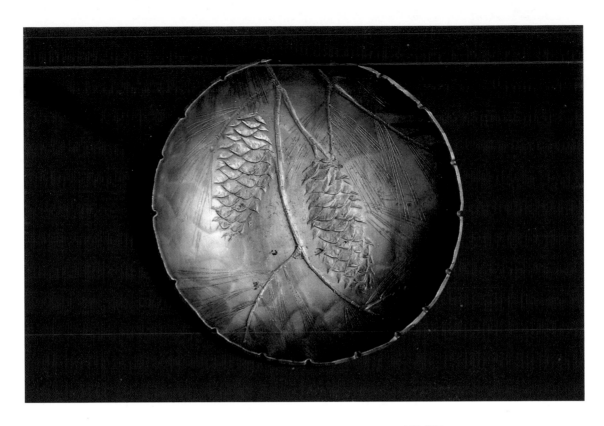

Small bowl, Wendell August Forge trademark. $30-$35.

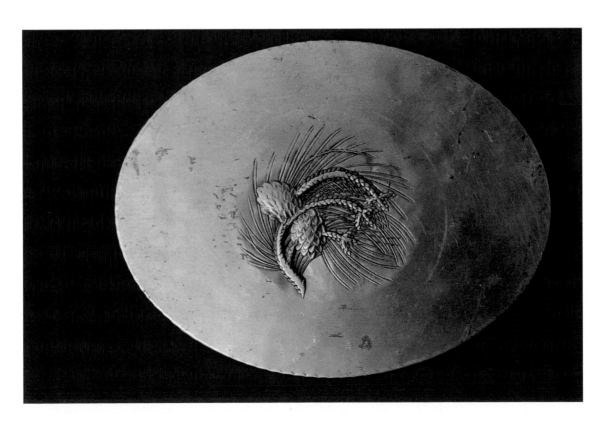

Hot pad, Everlast trademark. $15-$18.

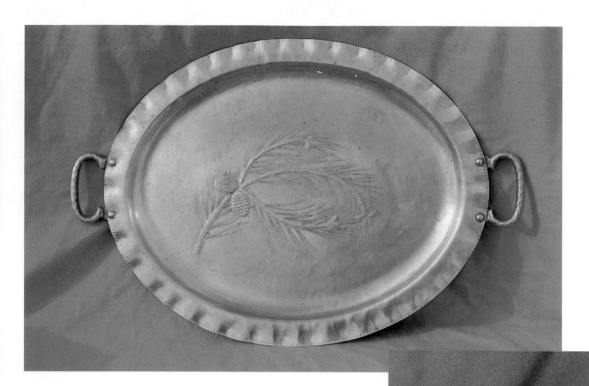

Large tray, 16 by 20 inches excluding handles, Everlast trademark. $30-$45.

Basket with pine cone design, Hand Forged trademark. $17-$22.

Long tray, 8 by 18 inches excluding handles, Everlast trademark. $28-$36.

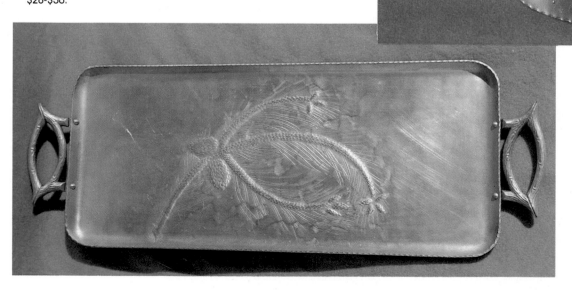

Chapter Thirty-Five:
Plates and Platters

It is hard to distinguish between the pieces that might have been called plates and those called platters when they were first made. A catalog or any kind of advertising would help, but usually the more unusual pieces were illustrated in the catalogs. In the days when aluminum giftware was at the peak of its popularity they were probably used for that which they were made, which was serving everything from sandwiches and cookies to snacks at cocktail parties. Because of their unbreakable nature, they were used more for picnics and for serving cookies to kids in later years.

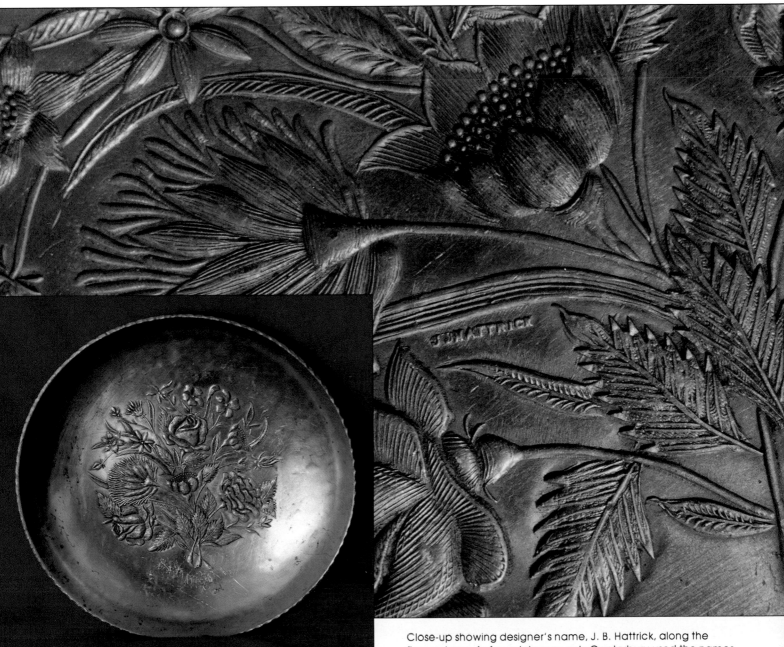

Plate, floral design, Canterbury trademark. $25-$30.

Close-up showing designer's name, J. B. Hattrick, along the flower stems. As far as is known only Canterbury used the names of the die makers in the design. Only two were so honored, Hattrick and C. C. Pflantz.

Plate, grape design, Everlast trademark. $17-$23.

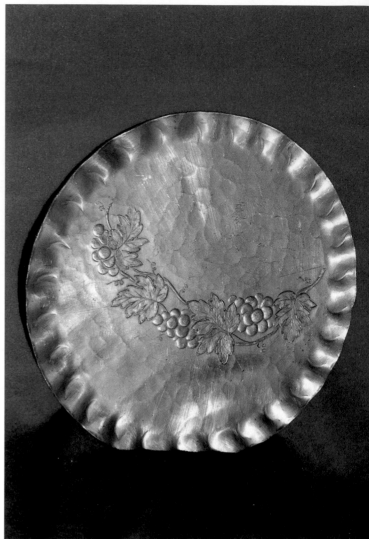

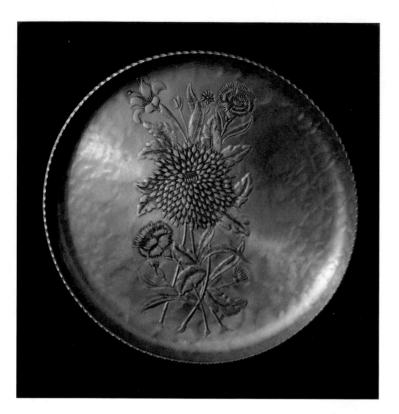

Plate Canterbury trademark. $18-$22

Plate, Hand Wrought Aluminum trademark. $15-$18.

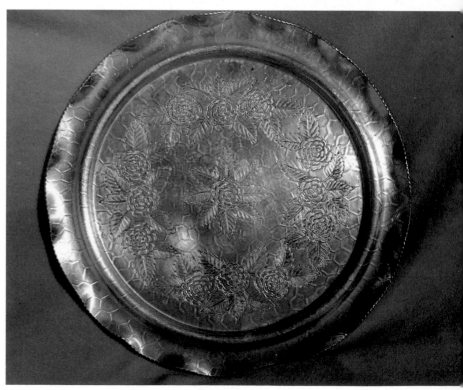

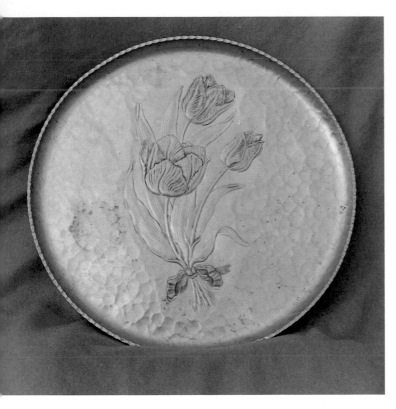

Plate, tulip design, unmarked, unmistakenly Rodney Kent was the maker. $18-$26.

Plate, Aluminum by Federal Silver Co. trademark. $16-$24.

Plate, Wendell August Forge trademark. $25-$30.

Plate with open work border. $17-$20.

Chapter Thirty-Six:
Postcards and Pictures

When postcards could be sent through the mail for only one cent postage, they were made of every material from leather to wood. Of course, the majority were made of heavy paper, but other materials were used to make novelty cards. This illustrated aluminum card was never mailed as it is, but was mailed in an envelope as indicated by the message without an address. It does have an undivided back which dates it as a rather early one. The floral designed plaque or picture is the only one of this kind we have ever seen. It seems it must have had the design stamped on it similar to linens that were stamped for embroidery with directions for the correct way to finish on the label on the back. Interest-

ingly, the price was written on the back in pencil, 40 cents at first, but was reduced to 35 cents for a quick sale, no doubt. The little hanging picture of the church, and the pastor and his family would seem to date around the 1920s judging by the hairstyles and the ribbons in the girl's hair. Some ladies' group in the church could have had them made to sell as a fund raising effort, or it is possible the pastor had them made to give to his favorite members. None of these things were expensive, therefore they weren't saved like some of the more expensive things of that era which helps to explain why there are so few of them today.

Aluminum plaque with church scene and pastor's family. Judging by hairstyles it dates in the 1920s, 4 by 6.5 inches, unmarked. $20-$25.

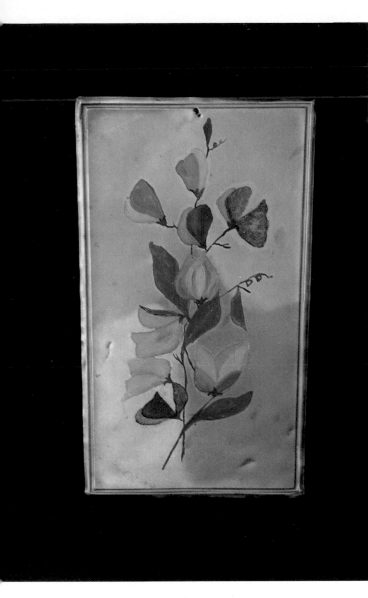

Aluminum plaque, 5 by 9 inches, stamped design done by owner. $18-$23.

Aluminum postcard, made by Owens Bros. Hillson Co., Boston, Mass. $8-$12.

Back of plaque with instructions for painting.

Undivided back of aluminum postcard.

Chapter Thirty-Seven:
Questionable Pieces

Maybe "questionable" is not the correct word to use here, but if you do question the piece, don't buy it until you are sure. The hammered tray is a questionable piece because it is heavy, heavier than an aluminum tray should be. It is also heavy because it is made of tin. Another tray exactly like this one has been seen but it has metal handles rather than wooden ones. At first glance it looks exactly like hammered aluminum. So the first test is to look for any area that might have a little rust. Remember, tins rust and aluminum corrodes. If it is a good piece, which many are, and there is no rust or corrosion, use a magnet. It will adhere to the tin but not to the aluminum. Another item to watch for is the containers for coffee, tea, or sugar that have been shipped in from England. They are very attractive and can be used with a collection of aluminum, but they aren't aluminum. Give them the same test given to the tin tray. Be doubly careful when two pieces are together, such as the child's aluminum cup and the tin saucer. In other words, check both pieces when buying a set. Chances are the dealer isn't even aware that two metals are represented.

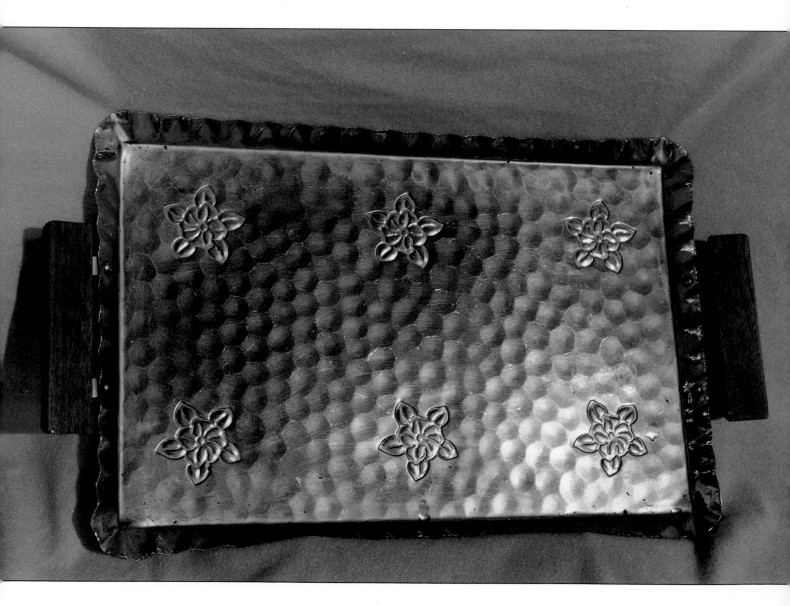

Tin tray, hammered with aluminum design, unmarked. $10-$12.

Tin saucers from child's tea set, unmarked. Set of 6 $12-$15.

Aluminum cup, tin saucer, difficult to distinguish one from the other, unmarked.

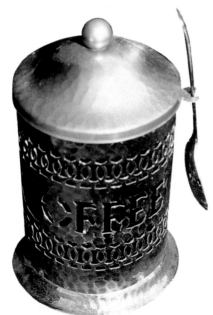

Container for coffee, tin, hammered, England-made. $15-$19.

Two-piece tin crumber, unmarked. $6-$8.

Chapter Thirty-Eight:
Rodney Kent Patterns

Many Rodney Kent pieces will not have a stamped trademark, as it probably once had paper labels which have long since disappeared in the dishwater. But these pieces are easy to recognize after one has spent a little time studying and comparing them. For one thing, the pieces have been made of a good quality aluminum -- the handles, made to resemble grosgrain ribbon, is their trademark. And if that isn't enough, the majority of pieces will have a tulip design. It is very distinctive work. It is also a pattern that has to be carefully watched because the maker, Rodney Kent Silver Company, which is stamped on many pieces has confused both buyers and sellers. A large number of these pieces have been seen in shows

and malls labeled "sterling silver," and priced accordingly. It is pretty, and the almost perfect pieces do look like silver, then the trademark indicating it was made by a silver company cinches the fact, at least for some, that it is silver. But the pieces with the ribbon handles and tulip designs are aluminum.

Set of coasters, ribbon handle on caddy, Rodney Kent trademark. $23-$27

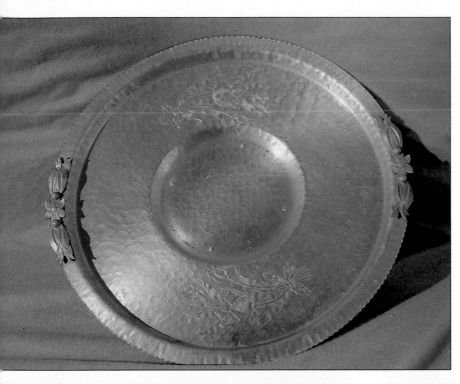

Lazy Susan, Rodney Kent Silver Co. trademark. $27-$35.

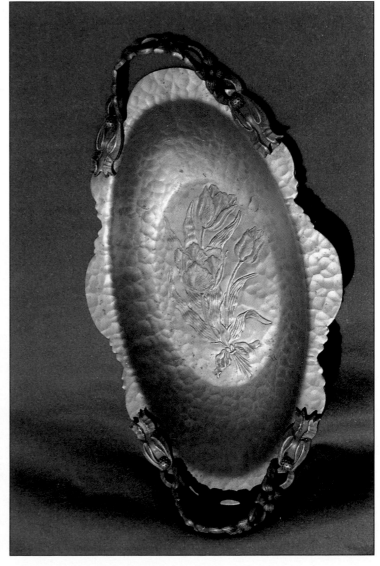

Small basket. $15-$19.

Bread tray. $15-$20.

Round tray. $25-30.

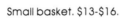

Small basket. $13-$16.

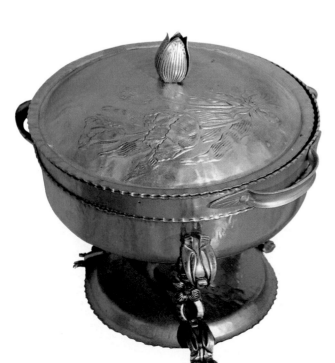

Chafing dish, all Rodney Kent, note tulip on cover. $28-$34.

Chapter Thirty-Nine:
Ships, Sailing

Sailing ships have always fascinated people, those living near the coast as well as those living inland. In an effort to attract as many customers as possible, the aluminum companies designed some pieces with ships.

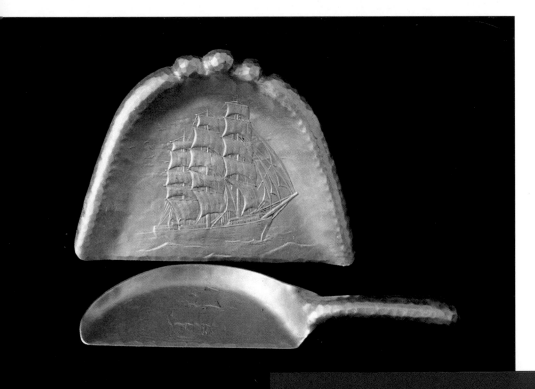

Two-piece crumber, World Hand Forged trademark. $18-$25

Coaster, Wendell August Forge trademark with Pat. apld. For underneath. $15-$20.

Chapter Forty:
Tidbit Trays

Tidbit trays were a necessity for the hostess in the days of home entertaining. They are still very attractive for serving, however they seem to be more popular for decorating at Christmas than for serving. The double and triple tiers are perfect for holding greenery and fruit. The silver of the aluminum peeking through the different colors of the fruit and greenery is very appealing.

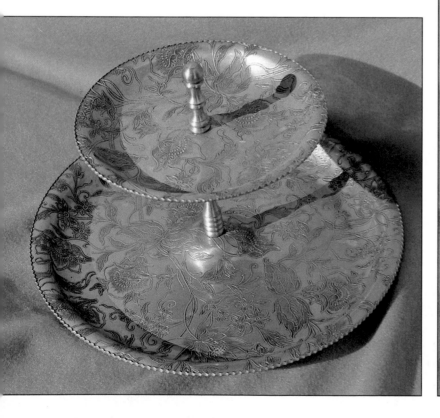

Tidbit tray, Hand Wrought Aluminum trademark. $19-$25.

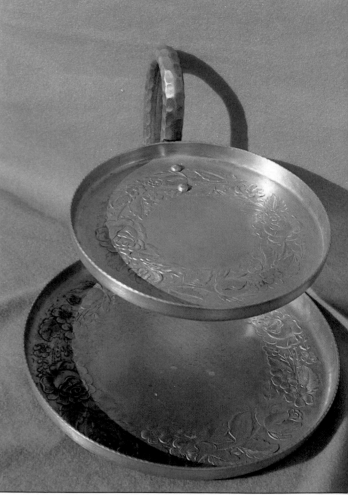

Tidbit tray, Everlast trademark. $25-$30.

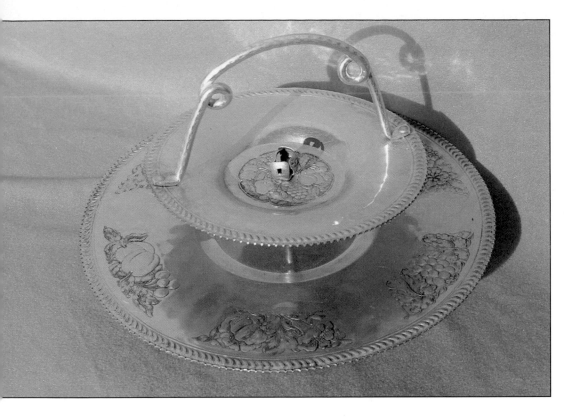

Tidbit tray, unmarked. $25-$30.

Tidbit tray, Wild Rose design, Continental
Silver Co. trademark. $23-$27.

Tidbit tray, Everlast trademark. $25-$30.

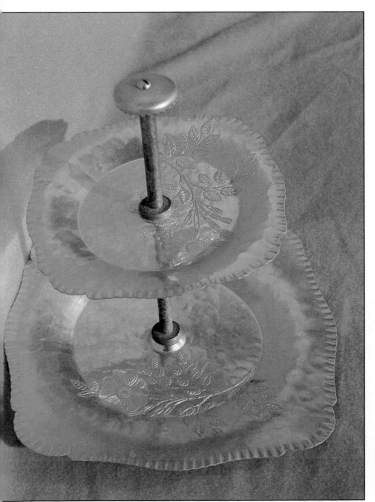

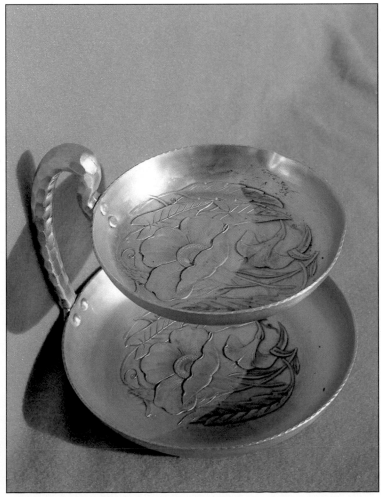

131

Chapter Forty-One:
Serving Pieces

While it lasted, aluminum making must have been very competitive, judging by the many pieces, styles, designs, and decorations used. Almost all of the pieces were in reality serving pieces, but some were more job oriented than others. For example, the very name well and tree platter indicates a serving piece, a piece for serving a meat dish, which in those days was an essential part of the meal whereas the condiment containers were also servers but they were only a convenience and not essential. Then there were the salad forks and spoons as well as pie and cake servers, all serving pieces.

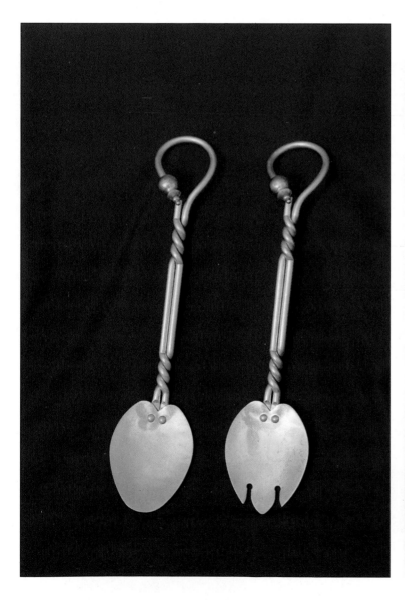

Salad set, unmarked but definitely Buenilum as indicated by the handles. $30-$45.

Pie server, Buenilum trademark. $18-$20.

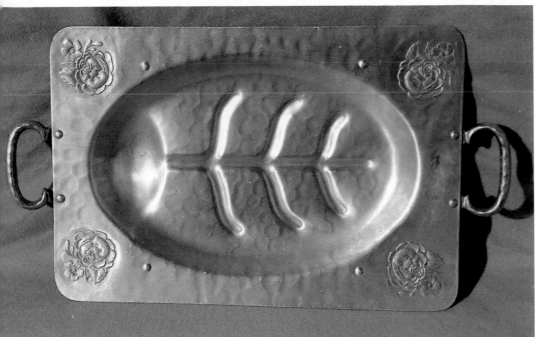

Well and tree platter, Everlast trademark.
$45-$60.

Cream and sugar on tray, unmarked. $22-
$25.

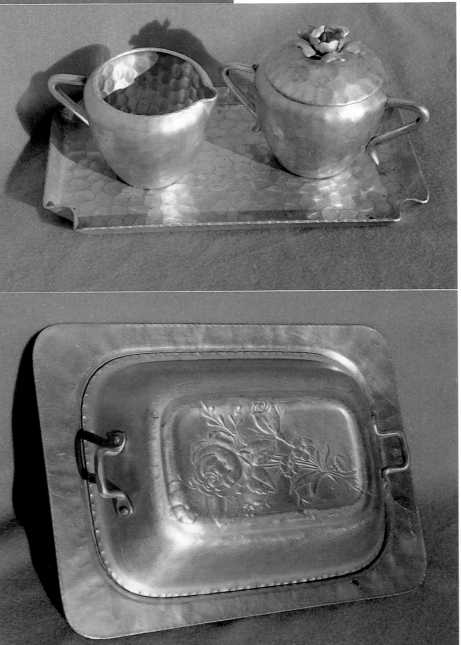

Small compote, Wild Rose pattern,
Continental Silver Co. trademark. $18-$25.

Covered vegetable, Everlast trademark
inside cover. $40-$45.

Well and tree platter, unmarked but distinct Forman Family design. $30/$40.

Three sectioned server, handle in center, Continental Silver Co. trademark. $18-$24.

Three sectioned dish, Forman Family trademark. $15-$18.

Chip and dip, Buenilum trademark. $25-$30.

Chapter Forty-Two:
Silent Butlers

Since silent butlers, especially aluminum ones, haven't been used extensively for the past twenty-five years, it might be surprising to young collectors to find how attractive and useful

they still are. They can be best described as a small container with a handle and hinged lid that is very useful for collecting crumbs. In their heyday they were used more for collecting ashes and the con-

tents of ashtrays, but so few people smoke today that they aren't needed as much. Silver and plated examples were very popular with the Victorian ladies who might have several. They were used to remove ashes, crumbs, and perhaps flower petals that may have fallen on the dining room table more than for any other chore.

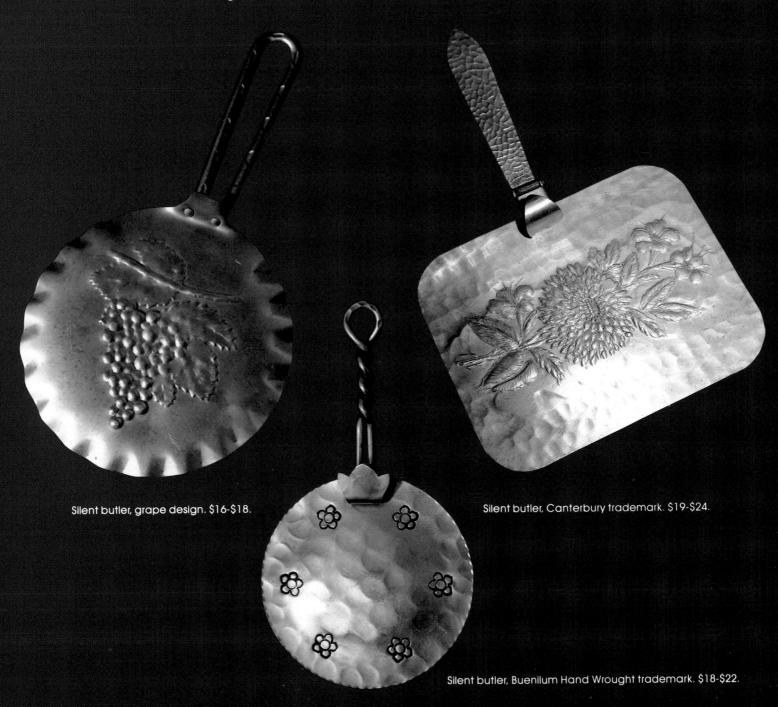

Silent butler, grape design. $16-$18.

Silent butler, Canterbury trademark. $19-$24.

Silent butler, Buenilum Hand Wrought trademark. $18-$22.

Silent butler, Continental Silver Co. trademark. $17-$22.

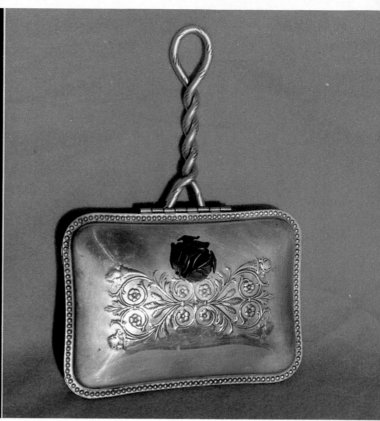

Silent butler, floral design with copper knob, unmarked. $15-$18.

Silent butler, Canterbury trademark. $17-$20.

Silent butler, cattail decoration, looks like silver, unmarked. $20-$24.

Chapter Forty-Three:
Smoking Accessories

Smoking accessories, the kind that ladies made in some of their craft projects, had long been an acceptable gift for them to give their gentlemen friends. But with the advent of aluminum giftware the manufacturers included a few pieces that could be used as gifts. As gifts, some of the ashtrays were quite pretty and very useful. Men probably preferred buying their own pipes, especially the ones with aluminum stems. They also would probably prefer selecting the cigarette lighter of their choice. Prior to that time men seemed to have preferred leather cigar cases, but quite a few aluminum ones were made including the one with the painted name of the town of Lisbon, Maine. It was probably a souvenir from one of the local fairs. Some of the older men remember when the single aluminum cigar case was given to the buyer of certain types of cigars. Not run-of-the mill cigars, but the more expensive brands. If that proved to be popular there is little doubt that some were also made for a straight sale, with no cigars included. For the cigarette smoker there were the aluminum cases that held the cigarettes after they had been removed from the pack. For those who wanted to keep their cigarettes in the original pack there was an aluminum cover that exactly fitted the pack. No aluminum cigarette cases have been seen with lighters included, that is, designed into the case, so chances are the smokers had to buy a lighter extra. Of course they had the choice of several aluminum lighters that are very light in weight. If the smoker preferred matches, there was an aluminum cover for a penny box of matches.

Single aluminum cigar case, some were free with certain brands while others were sold over the counter. $15-$18 each.

Two single aluminum cigar cases, still in satin lined gift box $25-$40 for the two.

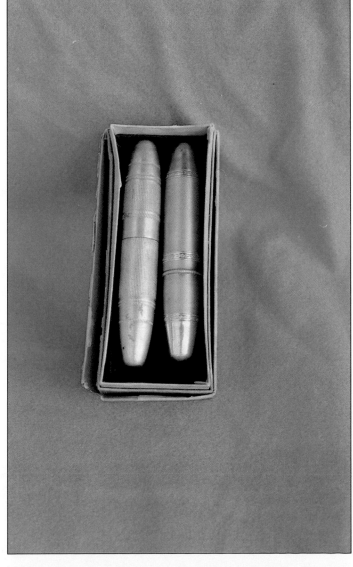

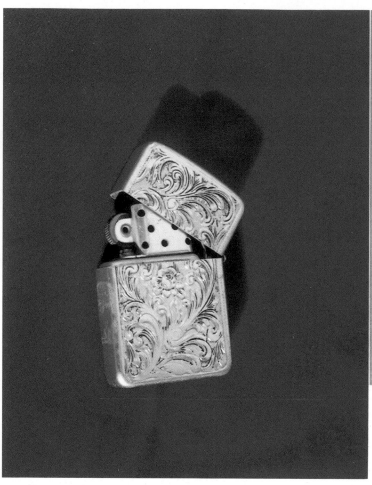

Heavy cast aluminum ashtray with owl decoration. Made in Germany. $9-$12.

Aluminum cigarette case, made in Japan. $15-$18.

Aluminum cigarette lighter, very light weight. $9-$12.

Ashtray, Forman Family trademark. $8-$10.

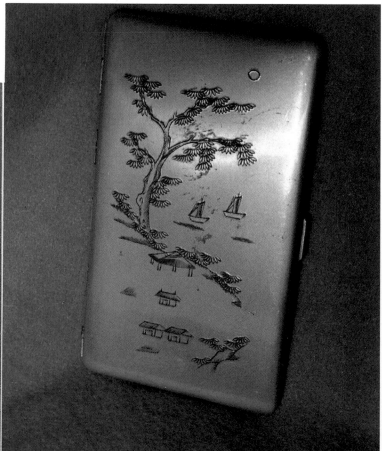

Aluminum cigar case for three cigars. Whether the location Lisbon, ME, was put on originally or later is unknown. $25-$30.

Pipe with aluminum stem, ashtray with Masonic emblem, unmarked. Pipe $10-$12, ashtray $7-$9.

Cover for penny match box, unmarked. $10-14.

Aluminum cigar case for three cigars, unmarked. $25-$30.

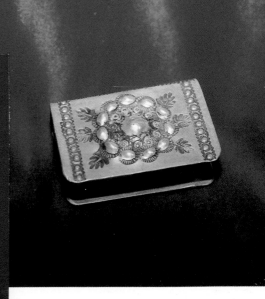

Chapter Forty-Four :
Toothpick Holders/
Salt and Pepper Shakers

These accessories were absolutely essential on the Victorian dining table. They might not be allowed to use their toothpicks at the table, but there was nothing which said they couldn't carry them in their mouths until they left the table, a custom many followed. Some of these pieces are leftovers from the Depression glass period While others are from the fair or carnival era when bright cutting and the name of the town was important to establish where they came from. The custom of using fancy salt and pepper shakers originated about the time people stopped using salt dips. The first shakers are believed to have been glass or silver with other materials following. One of the last was aluminum. Toothpick holders followed approximately the same path. Today there are collectors who are only interested in the shakers while another group searches for toothpick holders of any kind.

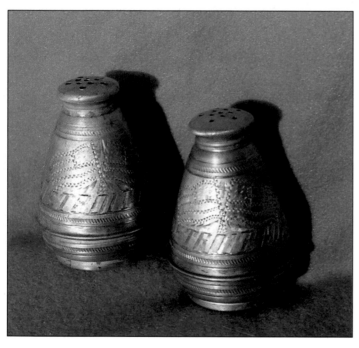

Salt shaker shaped like a thimble, unmarked. $5-$7.

Salt and pepper shakers, bright cutting, Detroit, Michigan, probably from a fair. $15-$18.

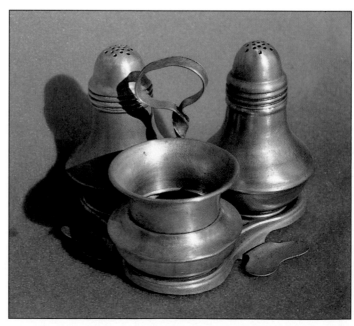

Salt and pepper shaker and toothpick holder in stand, unmarked. $18-$20.

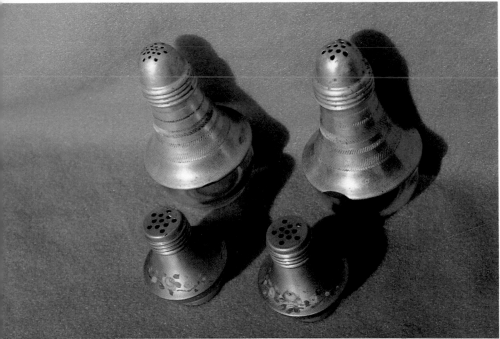

Salt and pepper shakers, unmarked. $10-$18 pair.

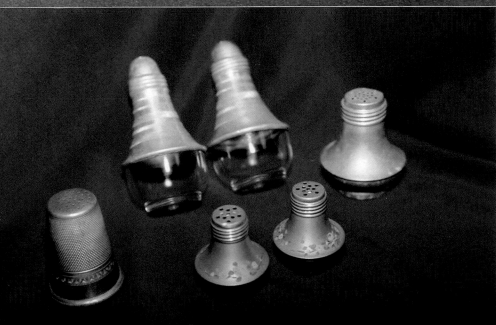

Assorted salt and pepper shakers, unmarked. Painted $8-$10 pair, glass bottomed $15-$18.

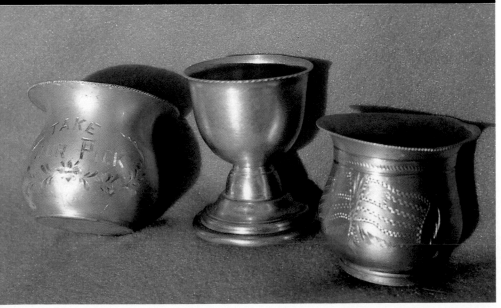

Three types of aluminum tooth pick holders. Bright cutting "Take your Pick" on left, flag on right, center stemmed. $8-$15 each.

Chapter Forty-Five:
Tourist Art

The term "tourist art" is so much classier, we think, than the term "souvenirs," which is generally used to describe these kinds of pieces. It establishes the owner as a traveler who has visited the famous places -- or at least they recognized the places shown on the pieces and wanted to own them. Not only have some of these people traveled, they also have brought things home from those travels, things that can be classed as art, not fine art, but art neverthe-less. Put the two together and it somehow makes the collecting of ordinary souvenirs a worthwhile venture. Aluminum items in this category range from small plates and trays with historical places pictured on them to plaques filled with handsome handmade aluminum weapons from the Philippines. They come in two sizes and can definitely be classed as Tourist Art.

Tray, exquisite workmanship, Wendell August Forge trademark.
$20-$25.

Souvenir or tourist art piece made in two sizes — 6 and 7.5 inches, Luzern-Kapellbrucke on front. $12-$17.

Tray, souvenir from Gettysburg, PA. $8-$12.

Aluminum tray depicting Mt. Vernon, only mark Switzerland. $15-$20.

Small 4.5 inch tray, Liechtenstein, Sigg Signal, Switzerland $10-$12.

Small plaque from the Philippines, probably brought back by a serviceman. Only twenty weapons on this one. $45-$55.

Larger weapons plaque from the Philippines, has total of thirty-one weapons, each identified, all weapons made of aluminum etched. $50-$75.

Tray, Wendell August Forge trademark, made for Pullman Incorporated. $19-$24.

Tray, cheaper piece of tourist art, Lom Starkyrkje only identification. $5-$6.

One of the favorite means of travel during the Thirties, Forties, and Fifties was by train. Not everyone had an automobile at that time, and those who had one didn't always trust it to make long trips. They preferred to go by train. The trains at that time weren't exactly dust and smoke free which meant that hands, and sometimes faces as well had to be washed often. That meant the passengers had to bring their own soap. What better way to take it than in a covered, aluminum soap dish? If one had their own quarters they often had an aluminum soap dish that fastened on the wall. From around 1920 onward mothers carried folding, aluminum drinking cups so their children wouldn't have to drink from public fountains.

Covered soap dish, unmarked. $7-$9.

Covered, folding drinking cup, unmarked. $6-$9.

Chapter Forty-Seven:
Trays, Oblong

So many aluminum trays were made that it was decided to divide them by shape, as hopefully it would make them easier to classify and identify. Whether or not it made any difference in the way they were used is unknown, but apparently trays were one of the most popular items in aluminum giftware. Their large size also made the gift very impressive.

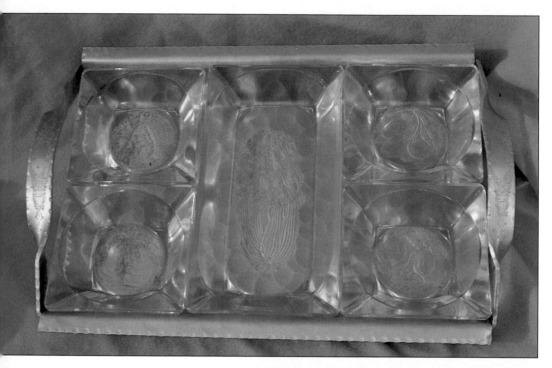

Tray, five serving dishes, stamped on back "Keystone aluminum hand hammered, patent pending, 310, design patent 121489." 10 by 13 inches. $50-$65.

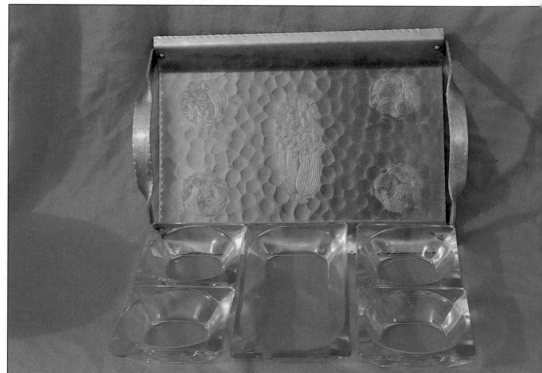

Tray showing designs without dishes.

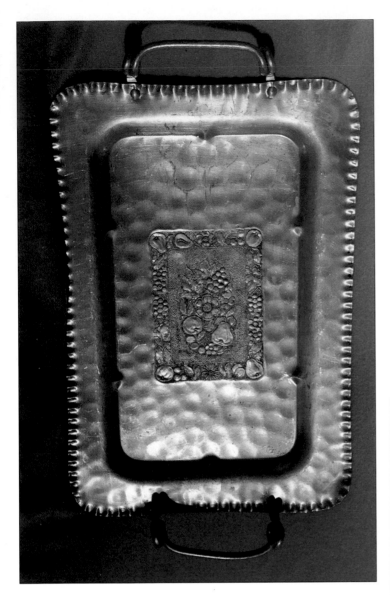

Tray, 10 by 15 inches, fruit and flower design in center, Cromwell Hand Wrought Aluminum trademark. $30-$38.

Close-up of center design in tray.

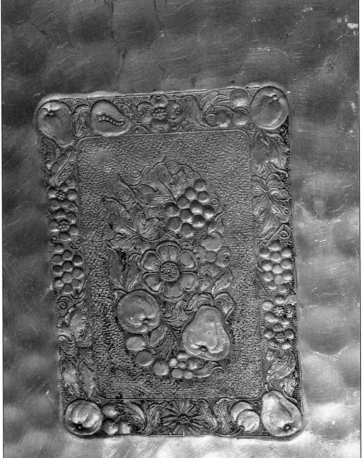

147

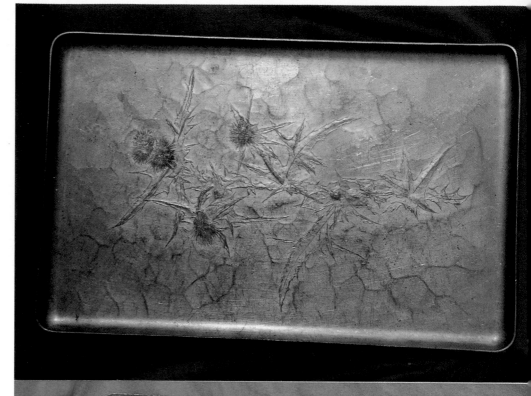

Oblong serving tray, 9 by 14 inches, Wendell August Forge trademark. $20-$27.

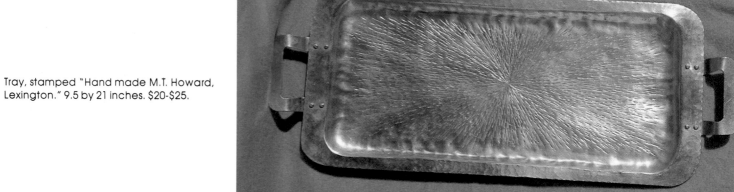

Tray, stamped "Hand made M.T. Howard, Lexington." 9.5 by 21 inches. $20-$25.

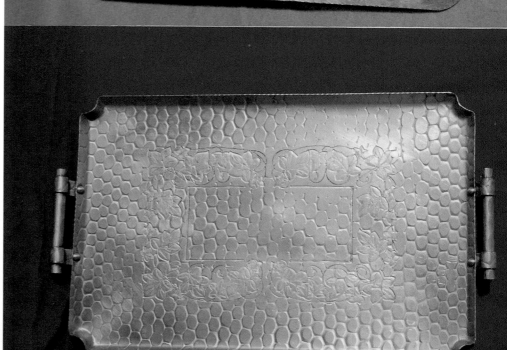

Oblong serving tray, leaf design, 11.5 by 15 inches, World Hand Forged trademark. $15-$18.

Tray, all-over design, Keystone Ware Paisley Aluminum trademark. $25-$30.

Set of 4 medium quality tray still in original box. Unmarked, described on box as Janis Aluminum Canapes, same design on box as on trays. $12-$17 in original box.

Medium sized tray, Good quality aluminum, unmarked except for numbers 5020. $19-$25.

Tray, 8.5 by 13.5 inches, Designed Aluminum trademark. $16-$19.

Canape trays, set of four, Everlast trademark. $17-$20 set.

Tray, advertised in the Fifties for 50 cents and a label from some products. Unmarked. $5-$7.

Tray with fruit, flower, and butterfly design, Finished Aluminum trademark. $22-$27.

Tray with intricately wrought design in the center, Cromwell Hand
Wrought Aluminum trademark. $35-$45.

Close-up of center design.

Tray, Silvercrest by Everlast trademark. $18-$22.

Tray, 12 x 18.5", fruit, flowers, butterflies, Hand Polished Aluminum trademark. $35-$45.

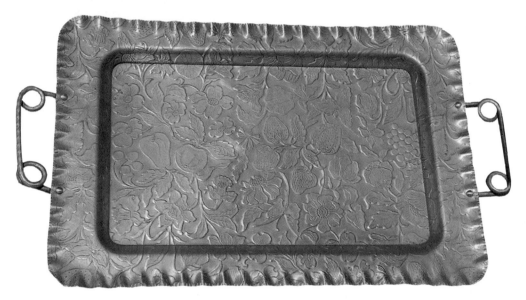

Tray made of good quality aluminum, but lacking in design. Palmer Smith trademark, 9.5 by 14.5 inches. $25-$30.

Chapter Forty-Eight:
Trays, Round

Sometimes it is difficult to sort out the round trays from the plates and platters, however it seems the 1best way is to look for the recessed place in the center of the round trays. When new, it held a fancy glass dish, a sectioned dish, a dish with a fancy design, or perhaps just a plain one. Today the majority of them will be found without the glass dish, proving again that the aluminum tray would outlast several glass dishes. Occasionally trays will be found with the original dish which helps the collector to identify the type dish needed to complete the set.

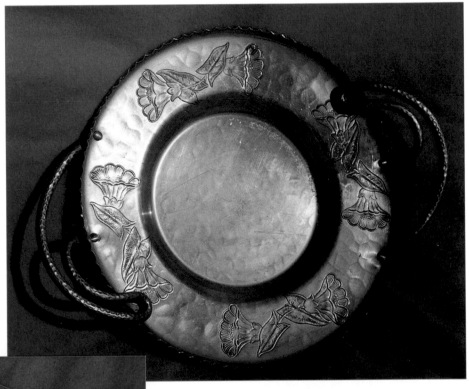

Round tray, Farberware trademark. $23-$30.

Round tray, Canterbury trademark. $19-$28.

Round tray, 9 inches diameter, Farberware trademark. $14-$18.

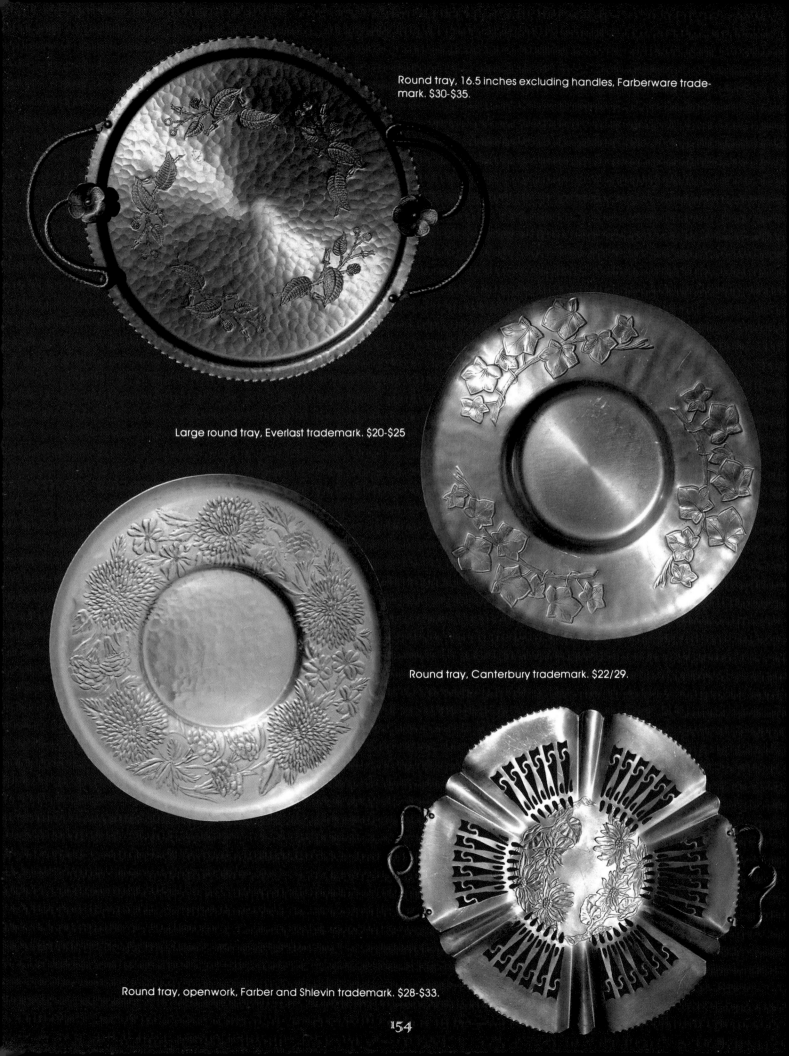

Round tray, 16.5 inches excluding handles, Farberware trademark. $30-$35.

Large round tray, Everlast trademark. $20-$25

Round tray, Canterbury trademark. $22/29.

Round tray, openwork, Farber and Shlevin trademark. $28-$33.

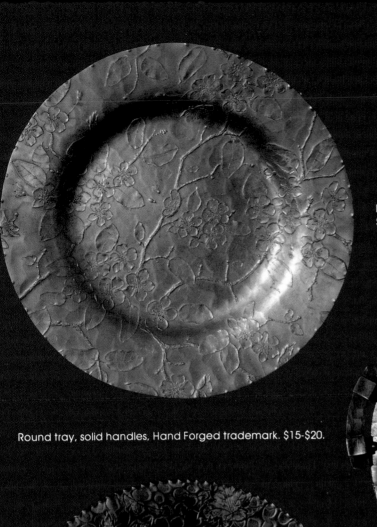

Round tray, dogwood design, Wendell August Forge trademark. $30-$38.

Round tray, solid handles, Hand Forged trademark. $15-$20.

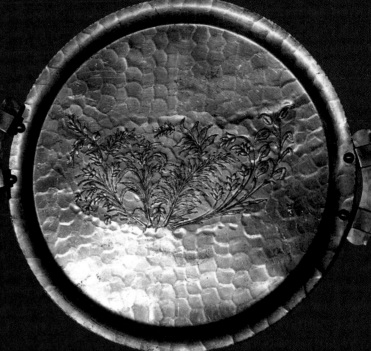

Round tray, vine with grapes, apples and pears design, Designed Aluminum trademark. $18-$27.

Round tray, Shup Laird Hand Wrought Argental trademark. $18-$24.

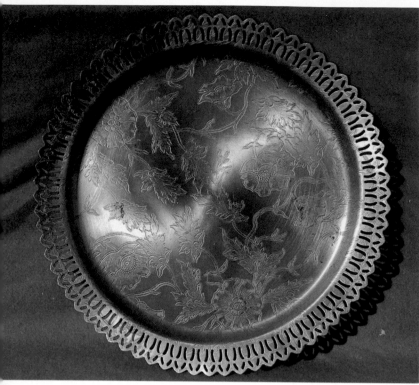

Round tray, openwork border, Royalty Aluminum Ware trademark. $15-$20.

Round tray, 10 inches diameter, four different kinds of leaves, Everlast trademark. $15-$19.

Round tray, running antelope, Everlast trademark. $24-$30.

All over floral design with glass in center, Hand Finished Aluminum trademark. $25-$33.

Round tray, Buenilum trademark. $20-$25.

Round tray, grape border, 18 inches diameter, Everlast trademark. $25-$30.

Tray, dogwood design, Admiration Products Co., NY trademark. $20-$25.

Tray with chain border, Everlast trademark. $17-$24.

157

Chapter Forty-Nine:
Trays, Square

Square trays are not nearly as plentiful as the round or oblong ones but they can be used in nearly as many ways. Again the recessed place in the center usually held a glass container of some kind. Then there were some which were made to be used without the glass container. They were made to be used just as they were with no additions. Proof that some aluminum giftware, actually most of it, was a popu- lar wedding gift and that it was sold in some of the better stores was confirmed when the hammered tray with the five-sectioned dish (illustration) was found. The pieces were still wrapped in tissue, rather yellow, and in a box from one of the leading jewelry stores in the town. A notation on the back revealed that it was a wedding gift and who it was from.

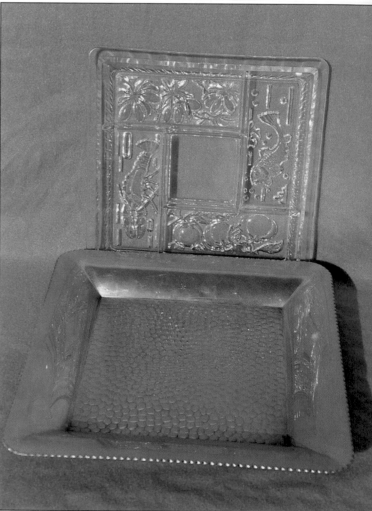

Square tray, Everlast trademark. $20-$25.

Square tray with five-section glass container, When found was still in jewelry store box and marked "Wedding Gift." Had been stored for years. Made in Spain. $35-$40.

Square tray, Everlast trademark. $20-$25.

Chapter Fifty:
Miscellaneous

Many of these pieces would fit loosely into other categories, but this section was created to find a place for the two small bowls with aluminum covers and underplates and the two without underplates. The last two probably had underplates at one time and they have simply been lost. Through the years we have heard all the discussions about the uses for these pieces, the original uses. Some swear by the theory that they are candy dishes while another group declares they were made to be used as powder jars on milady's vanity. Another theory is that they might have been made to use on the dining room table to hold some kind of condiments or relishes -- maybe butter. Until a catalog is found, or someone remembers what they were used for originally, they will probably be used for whatever purpose the owner decides is necessary. Compotes aren't all that plentiful, so they have been lumped into this category as well.

Glass bowl with three sections and waterlily decorated aluminum cover, Everlast trademark. $16-$20.

Small covered glass dish, unmarked. $15-$19.

Tray or underplate for glass container with aluminum cover, same design as tray, Hand finished Aluminum trademark. $35-$45.

Glass dish with aluminum cover and underplate, Rodney Kent Silver Co. trademark. $22-$29.

Low compote, unmarked. $11-$14.

Glass dish with aluminum underplate and cover, Rodney Kent Silver Co. trademark. $23-$28.